# A CRICKETER'S VIEW

For Pieter Dickson, Derek Semmence,
my parents Peter and Val Speight
and Lisa

# A CRICKETER'S VIEW

## A COLLECTION OF PAINTINGS BY MARTIN SPEIGHT

TWO HEADS PUBLISHING

First published in 1995 by

Two Heads Publishing

9 Whitehall Park

London

N19 3TS

Copyright © Martin Speight 1995

Photograph on Page 8 by Adrian Murrell, Allsport

Book design by Lance Bellers

Printed by Caldra House Ltd., Hove, Sussex

Bound by Marba Bookbinders, London

ISBN 1-897850-26-3

All press clippings have been taken from Martin Speight's
scrapbooks. It has not been possible to identify the source
of individual clippings and we apologise if we have
inadvertently infringed copyright.

# THE PAINTINGS

George Cox

Lewes Priory Under Snow

Ansty

Hurstpierpoint College

Staplefield

Horsham (two watercolours)

Lunchtime – County Ground, Hove

From The Deckchairs – County Ground, Hove

The Foster's Oval

Indian Palace – Jamnagar

Colombo – Sri Lanka

Nuwara Eliya – Sri Lanka

Kandy – Sri Lanka

Basin Reserve – New Zealand

Karori Park – New Zealand

Kelburn Park – New Zealand

Pukekura Park – New Zealand

Whitgift School

Lancing College

Cheltenham College

The Racecourse Ground – Durham

Durham Cathedral and Fulling Mill

Priory Meadow – Hastings

First Ball of the Day – County Ground, Hove

Lester – Tony Pigott

Frankie – Franklyn Stephenson

Dougie – Colin Wells

Eastbourne Under Snow

The Saffrons – Eastbourne

Ian Botham

Sir Richard Hadlee

Wasim Akram

Imran Khan

The Four Sirs – Sir Donald Bradman,

Sir Garfield Sobers, Sir Richard Hadlee,

Sir Colin Cowdrey

The Dream Ashes Test

Castle Park – Arundel Castle

Arundel Montage

Bert

Lurgashall

Before Play – Downpatrick

Lunchtime – Myreside, Edinburgh

Cuckfield

Castle Park – Colchester

Beaconsfield

County Ground – Taunton

County Ground – Northampton

Cartama Oval – Malaga

Trent Bridge – Nottingham

County Ground – Southampton

Scarborough Festival

Worcester Under Water

Lord's Under Snow

MY FIRST MENTAL IMAGE OF MARTIN SPEIGHT IS as vivid as one of his pictures. It is of a small, curly headed boy with his head bowed, crying bitterly after being out first ball in a Sussex Junior Cricket Festival match. The photograph, genuinely poignant, is the first image in this book and Martin, who has a sense of humour, might make it into a moving painting now that he has moved on from that disappointment to become one of the most vibrant cricketers not just in Sussex, but in England.

He could be said to have made an indelible mark on county cricket with one brief innings, the astounding piece of calculated hitting early in the 1993 NatWest Final at Lord's which raised the level of that game to the classic. He played with the bowling for a glorious hour in the morning like a previous darling of Lord's, the immortal Denis Compton.

Had Martin not laid about the bowling with such imagination and disregard for the conventional, it might have been just another one-day match. Sussex, batting first, might have scored 250 and been pleased with it. Warwickshire might have got the runs off the last over. Instead, Sussex scored 321 for six (Speight 50 off 51 balls) and Warwickshire still got the runs in the last over: 15 of them.

I very much hope, however, that this innings alone is not what he is remembered for. Such talent deserves to be seen more often in the West End rather than in provincial theatres of cricket. When the 1995 season started the hope of Sussex supporters was that Martin might do well enough to catch the eye of the England selectors for the World Cup in India, Pakistan and Sri Lanka the following winter. As I write this foreword, however, he is only completing his recovery from a mysterious virus. It is desperately unfortunate for him but fingers are crossed that there will still be time for him to make his mark on the second half of the season.

Playing cricket for a living, as this proves, can be very precarious, which is why Martin is lucky to have been granted a second great gift. How great can be estimated by anyone picking up and buying this book. I am no art critic but if this is not the work of a genuinely talented artist I am no cricket lover either. There is in these evocative paintings of cricketing scenes something of Canaletto's eye for detail, light and topography.

Comparisons with Compton and Canaletto! I had better stop there or the boy will become big-headed. Good luck, however, to painter and publisher. It will be surprising if this innings does not become a classic, too.

Christopher Martin-Jenkins

NEVER LET IT BE SAID THAT I DON'T TAKE MY cricket seriously. Back in 1979 Sussex Colts played a London Schools team at the Cox Oval and even now I vividly recall being out first ball. I sat on a bench and cried my eyes out, a sorry scene that the cricket photographer Adrian Murrell was on hand to record. I was consoled by the great George Cox who told me "It happened to me so often I must have cried in every loo in Sussex".

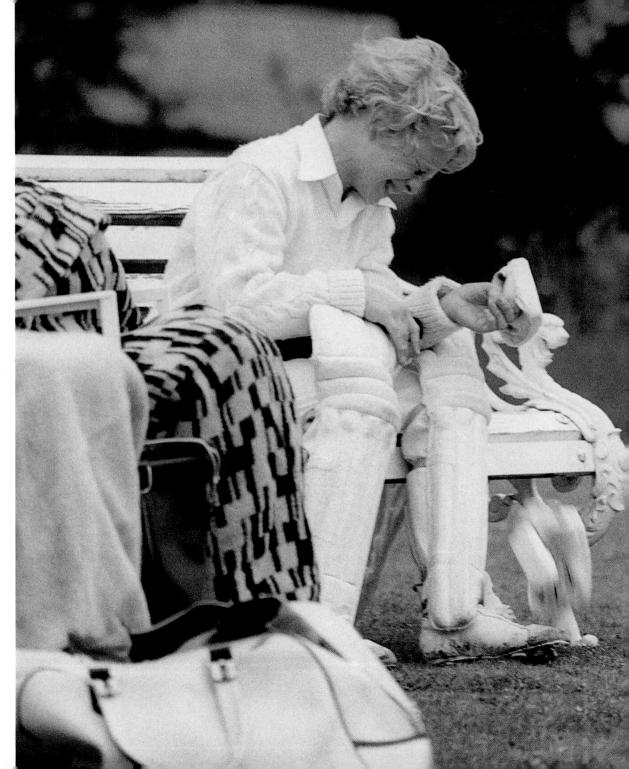

WHILST PRESIDENT OF SUSSEX COLTS, GEORGE Cox, the former Sussex batsman, created a cricket ground in a small oval-shaped field outside his home at Jacobs Post, Burgess Hill for Sussex youngsters to play on. I played at the Cox Oval as a junior and I had always wanted to paint the portrait of this former Sussex great.

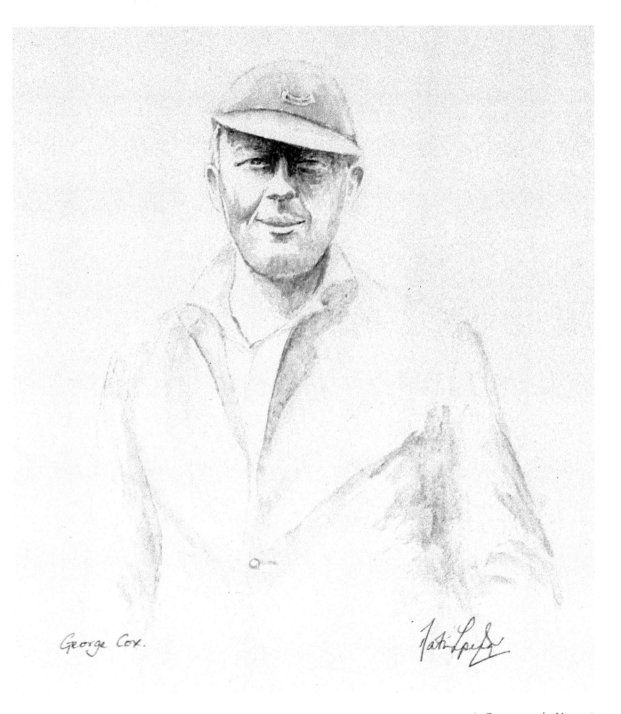

George Cox.

**George Cox**
Sussex 1931-1960

*Watercolour*
*8 x 6*
*1995*
*Martin Speight collection*

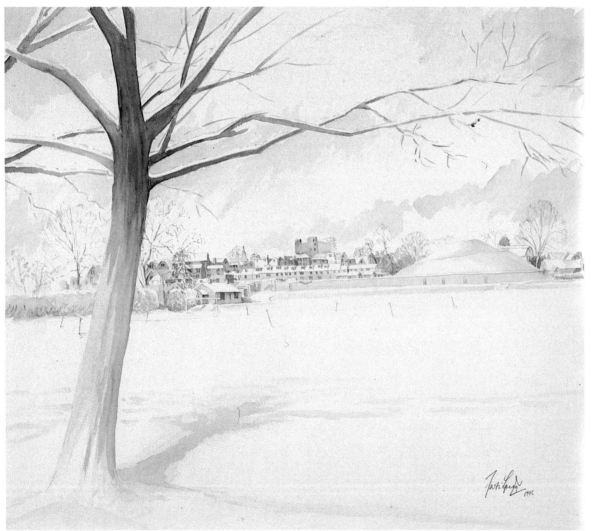

ANSTY AND LEWES ARE ALSO CRICKET GROUNDS that featured in my days as a junior cricketer. In an attempt to get all the first-ball dismissals out of my system early on, I played my first three 20-over schools games at Lewes (as an opening bowler I might add) and was out first ball in all three innings! I fared no better at Ansty, as in my fourth game I set off for a run having hit the ball to square leg and was run out when my box fell out of my trousers!

Nevertheless, I enjoyed returning later in life to paint these two charming grounds. Lewes is especially interesting, surrounded as it is by the Priory and Norman ruins.

**Lewes Priory
Under Snow**
*Watercolour*
*13 x 9*
*1994*
*Martin Speight collection*

**Ansty**
*Watercolour*
*13 x 9*
*1994*
*Martin Speight collection*

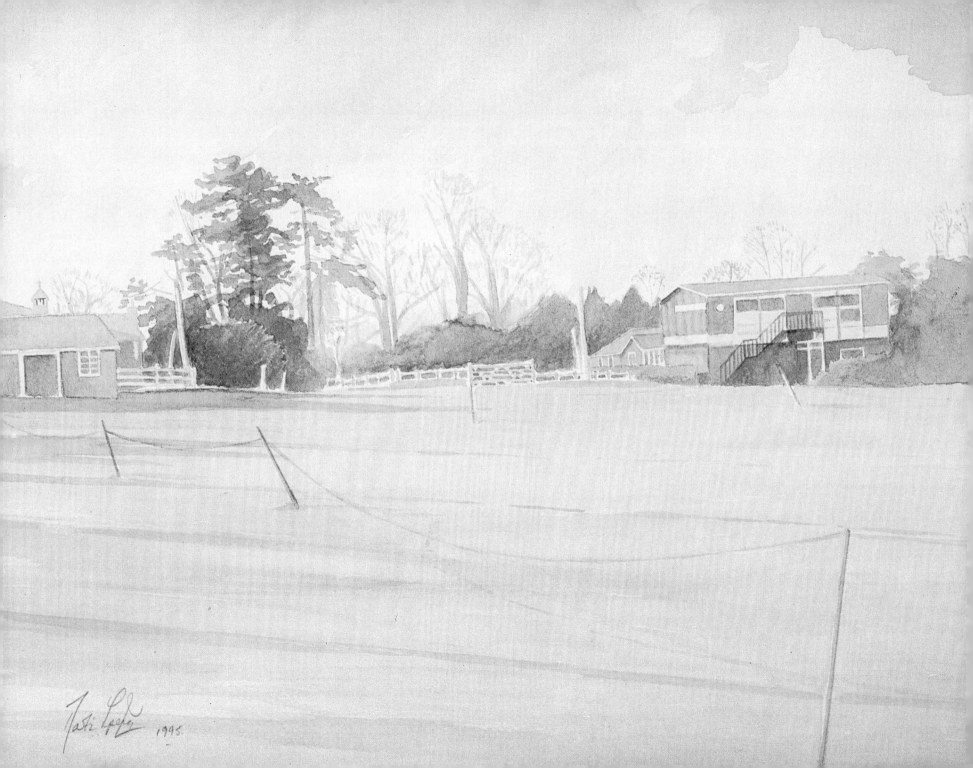

## History makers!

HURSTPIERPOINT COL-
LEGE won the Langdale
Trophy — a Sussex Schools
Knock-Out Cricket tourna-
ment — for the first time on
Saturday.
Hurst defeated East-
bourne by 108 runs in the 50
over final with opener Mar-
tin Speight cracking an un-
beaten 162.
Speight's splendid knock
included one six and 21 fours

as Hurst, winning the toss,
amassed 232 for 4, Matthew
Hastwell offered Speight
useful assistance in making
36.
Eastbourne never really
looked like reaching the
target and were dismissed
for 124 in 46.3 overs.
Off-spinner Simon Twine
was in fine form for the
home side claiming 4 for 28
in his 10 overs.

### JUNIOR CRICKET

On Sunday, July 13, in damp and
dismal conditions, Sussex enter-
tained London Schools and
thanks to the staff of Hurst-
point College, who kindly
provided the venue and worked
extremely hard to make a match
possible the game started
promptly.
Put in to bat, the visitors could
only total 57, with Steve Palmer
taking 3 for 15, John Price 3 for 5
and Edward Thesiger 3 for 8.

#### OUTSTANDING

Once again the Sussex fielding
was superb, an outstanding
display of wicket-keeping by
Andrew Green being a highlight
of the game.
This talented Sussex side made
nonsense of the conditions, and
scored the necessary runs for the
loss of only two wickets, Daren
Panto making 26, Steven Palmer
18 and Martin Speight an un-
beaten 18.
Sussex Team was: Steven
Palmer (St. Matthias), John Price
(Keymer and Hassocks, capt),
Edward Thesiger (Reigate),
Andrew Green (unattached),
Daren Panto (Preston Nomads),
Martin Speight and Barry Burt,
(Keymer and Hassocks), Robert
Prior-Wandesforde (Ditchling),
Nigel Clifford (Keymer and Has-
socks), Matthew Prince (Preston
Nomads) and Barry Crouch
(Burgess Hill).

## Hurst in quarter-finals

A 45 run victory over Kent
champions Eaglesfield put
Hurstpierpoint College into
the last eight of the
national Lords Taverners
Under 15 competition.
The Sussex side skittled
Eaglesfield out for 151 to
clinch their quarter final
place with Inman (3 for
19), Weatherley (2 for 19)

and McMillan (2 for 39)
doing most damage.

In previous rounds they
have been the champions
of Berkshire and
Hampshire, the highlight of
their run being a magnifi-
cent innings of 104 from
Martin Speight against
Beaconsfield.

HURSTPIERPOINT COLLEGE PROVIDED MY education both academic and cricketing. I went there at age 11, having had trials at Hove for the Sussex Under-11 squad. Derek Semmence, the former Sussex player, was cricket coach at Hurst College and he was instrumental in my progress as a player.

I was granted a scholarship to the senior school as the first Downs Scholar and enjoyed four years in the first team, having made my debut for them as a 13 year-old. My interest in art also developed at Hurstpierpoint and I was later commissioned by the Old Hurstjohnians to paint Cricket Week, to commemorate the opening of a new sixth form house. The original hangs in the foyer of the new building. The square is enormous and this painting shows the first-team pitch on the North Field.

**Hurstpierpoint College**

*Oil*
*36 x 24*
*1992*
*Commissioned by Old Hurstjohnians to commemorate opening of a new sixth form house at Hurstpierpoint College*

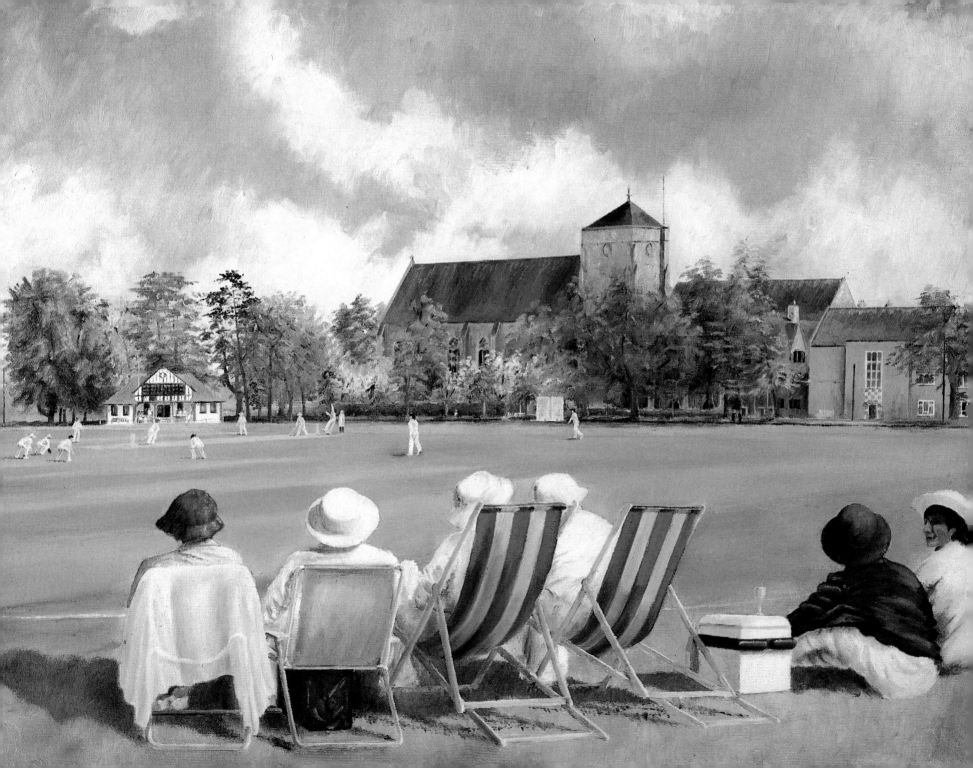

As a 12 year-old I played for Hassocks Seconds at Staplefield and I played my first club cricket there. It is a classic English scene with a cricket ground surrounded by trees and an old country pub, the Victory Inn, just over the boundary. Any young cricketer needs the support of their parents if they are to make progress and over the years playing here cost my father some money. Whenever I scored a half-century he was obliged by tradition to buy a jug for the pub.

I have a list of grounds which I one day intend to return to and paint. I was driving home from a county game on a balmy summer evening and I passed the ground. I needed no more invitation to stop the car and draw this classic village cricket ground. I then completed the oil painting in the studio.

* * *

A MAGNIFICENT 110 from Speight was the feature of Keymer and Hassocks II draw at Staplefield last Saturday.

Speight had useful support from Martin (28) and Smyth (25) as Hassocks reached 196 for 6 before declaring.

In reply, Staplefield just held out for a draw when they were 88 for 9 at stumps.

Bates (28) and Rothwell (27) batted well for Staplefield, while for Hassocks, Burt bowled well to take 4 for 28 with good support from Lumb (2 for 23).

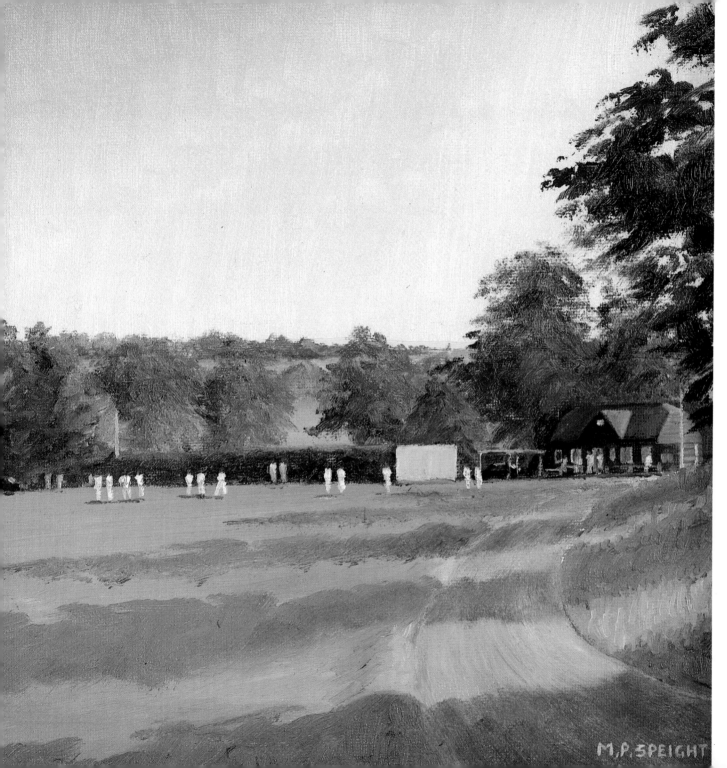

**Staplefield**
*Oil*
*36 x 24*
*1992*
*Martin Speight collection*

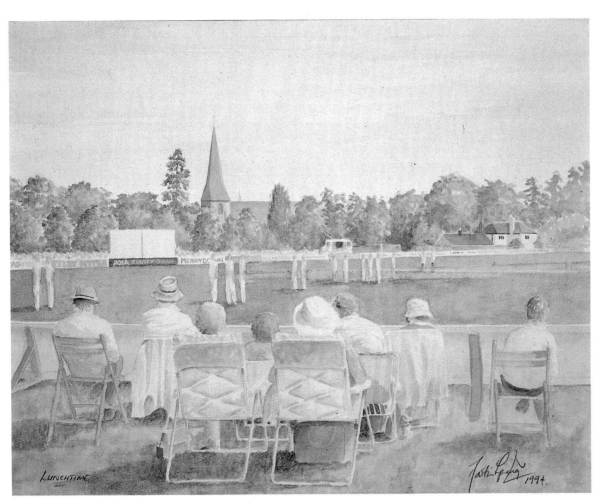

LUNCHTIME

HORSHAM IS A GREAT PLACE TO PLAY CRICKET. Matches here are often high scoring, there is always a festival atmosphere with good crowds and the pavilion is a delightful place to sit out and watch cricket.

I started playing league cricket at Horsham as a teenager and have enjoyed coming here year on year ever since. It is a ground where usually lots of runs are scored and this, along with sunshine, encourages good crowds. Against Durham in their debut year of first-class cricket, Sussex chased 275 in a Sunday League match at Horsham and we needed six runs to win with nine wickets down and only one ball remaining. Andrew Robson, from the north-east himself, calmly pushed the last delivery to

**Horsham**
*Watercolour*
*12 x 8*
*1994*
*Commissioned by*
*Sussex member*
*In private collection*

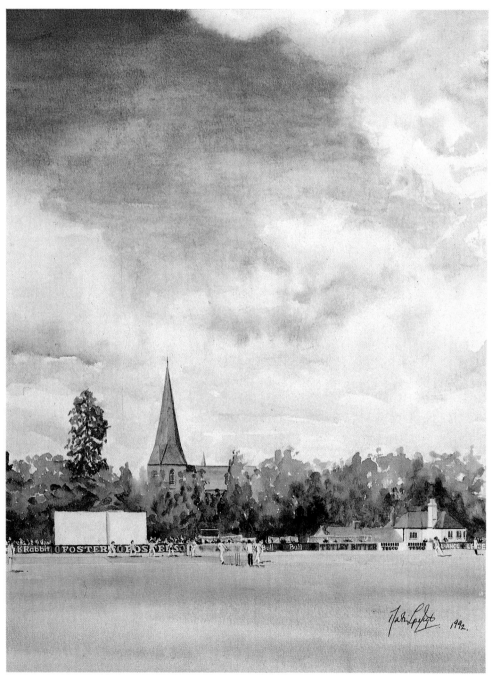

**Horsham**
*Watercolour*
*8 x 12*
*1992*
*Signed by Sussex and*
*Durham players from*
*1st first-class game*
*against Durham*
*In private collection*

third man and ambled down the pitch for a single without a care in the world. We lost by five runs! The very next day we needed to score 340-plus in a run chase to win a championship game and we did it.

In 1994 we had a tremendously exciting championship match against Lancashire. Wasim Akram took them towards the brink of victory by hitting a sparkling 98 chasing an improbable target of over 400 to win.

I first painted the Horsham ground to commemorate Durham's first visit to Sussex as a first-class county. The painting was autographed by both teams and the original oil painting was bought by Durham CCC to aid Sussex Cricket Youth Development.

YOUR HOME GROUND IS BOUND TO BE A SPECIAL place and is full of firsts for me. I made my first appearance for the senior side standing in as wicket keeper for an injured Ian Gould in a Sunday League game against Kent. It was a pitch of uneven bounce and I clearly recall the late swing from Imran Khan and the pace of Adrian Jones.

Hove was the setting for my first first-class wicket; Angus Fraser caught Gould bowled Speight in a boring draw against Middlesex. Strangely enough, my only other first-class wicket is Dermot Reeve! In 1990 I scored my maiden championship century at Hove, batting with a runner, against Glamorgan. The following year, 1991, I was awarded my county cap along with Ian Salisbury.

I have Christopher Martin-Jenkins to thank for my first one-man art exhibition at a Brighton gallery. Some of my paintings were on display in The Cricketers pub at Hove and were seen by the Daily Telegraph writer during a game against Hampshire. He promised me that if I scored a century the next day, he would ☞

## First ton for brave Speight

MARTIN SPEIGHT defied a knee infection to score his maiden championship century and lead a Sussex revival against Glamorgan at Hove today.

Following on 180 behind, Sussex reached 237-3 — a lead of 57.

Batting with a runner because of a poisoned leg, the spirited Speight made an unbeaten 118. He completed his century in 188 minutes, with 17 fours off 169 balls.

Speight's highest previous championship best was 88 against Leicestershire at Eastbourne last season.

Sussex

**Lunchtime**
County Ground,
Hove

*Oil*
*48 x 36*
*1993/94*
*Commissioned by Adams*
*& Remers Solicitors*
*In private collection*

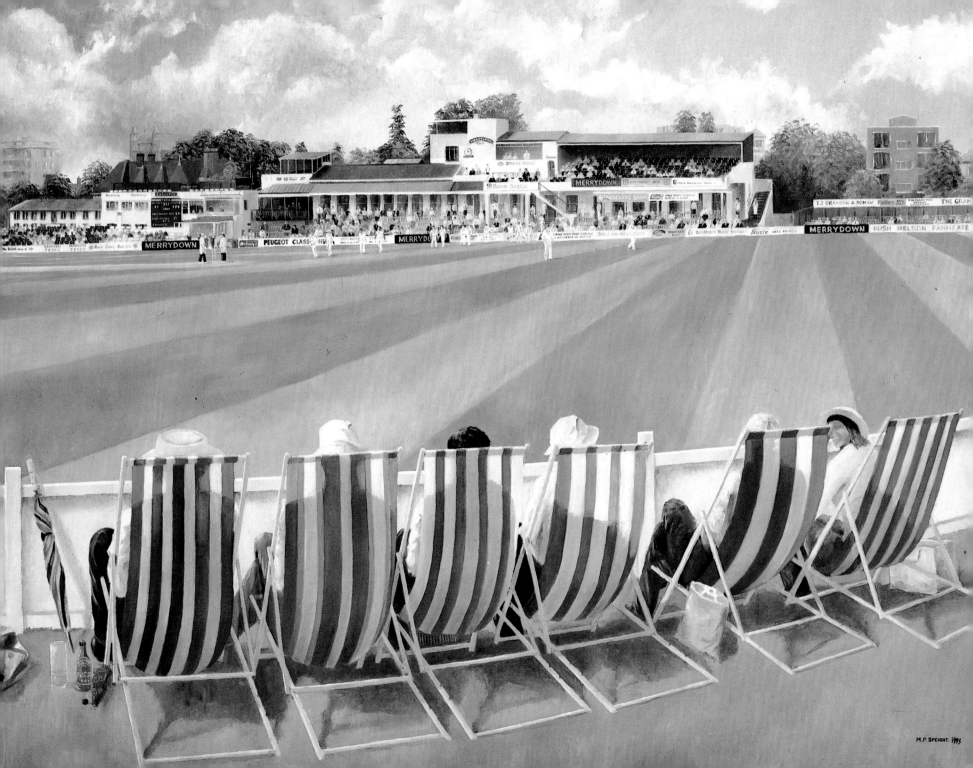

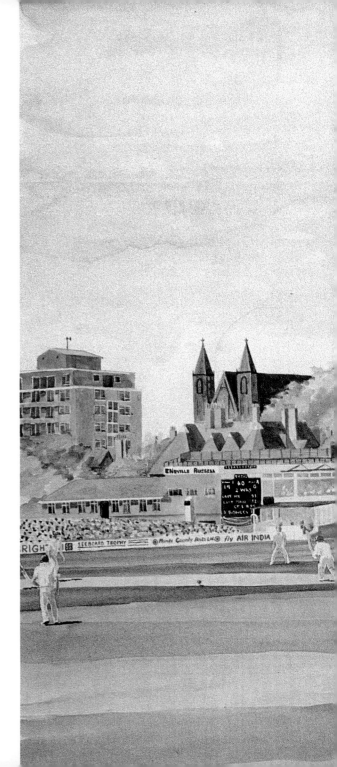

mention my paintings in his report. I scored 126 and received an approach from a Brighton gallery after my paintings had been mentioned in the Daily Telegraph the next day.

## Speight strokes carry stamp of true artistry

**By Christopher Martin-Jenkins at Hove**

*Second day of four: Hampshire (267 & 44-1) lead Sussex (279) by 32 runs*

FOR the second day running Sussex members baking themselves in the deck-chairs at the top end were privileged to see an innings of rare virtuosity as well as a glimpse of a sea of deepest blue.

Obliged to graft for the first part of his memorable innings of 126 by the sobering look of a scoreboard which at one point read 34 for five, Martin Speight eventually achieved for his team what Robin Smith had for Hampshire on the first day.

Norman Cowans, Martin Thursfield, Kevan James and Winston Benjamin all served Hampshire well in the morning, although Bill Athey, James Hall and Smith were each leg-before padding up, and Alan Wells cut at a very wide ball. The result was a lunchtime score of 78 for six.

This was ridiculous and Speight, with sound and doughty support from Ian Salisbury, set out to prove as much on a golden afternoon.

Sunny days at Hove were the ones on which Ranji used to display his genius to Edwardian audiences. It is hard to think that they can have had more pleasure than the 2,000 or so who watched Speight making 107, and Sussex 172, between lunch and tea. Like the magical maharajah, he is a batsman of exotic gifts and when he uses them with just a little discretion, he can be impossible to contain.

Speight has an exhibition of his water-colours on display at The Sussex Cricketer and such was the extraordinary panache of many of his leg-side strokes yesterday, no-one could doubt that an artist was at work.

He hit five sixes, reaching both his fifty and his hundred with reverse sweeps hit cleanly from the middle of the bat. For those who doubt his willingness to graft, let it be recorded that he took 35 minutes to get off the mark.

The unfortunate Shaun Udal, under the eye of Fred Titmus for possible selection for the England one-day party, was battered for 50 from his first eight overs when Mark Nicholas brought him on with the seventh-wicket pair, as it were, in full spate. Hampshire's captain had a ticklish problem because his seam and swing bowlers had made more than could have been expected in the morning out of Peter Eaton's ideal cricket pitch.

Matches like the one here late last season, when Sussex lost by seven wickets despite scoring 591 and 312 for three declared, have persuaded the ground staff that a little more grass on the square would not go amiss. The combination of that and careful rolling has produced a surface which gives everyone a chance.

There was still some movement with the new ball when Hampshire, in the last 26 overs of the day, put on 44 before Paul Terry was given out caught behind.

## A Speight of paintings

A SCORE of 126 runs led to Sussex cricketer Martin Speight being offered the chance to hold his first one-man art exhibition.

Martin, whose work goes on display at Gallery 44 in Upper Gardner Street, Brighton, this week, explained: "I was given a challenge during a match against Hampshire.

"Daily Telegraph sports writer Christopher Martin Jenkins saw some of my paintings in The Cricketers pub in Hove and said if I scored 100 during the next day's play, he'd mention my paintings in his report."

Martin surpassed this by 26 runs, guaranteeing a mention in the newspaper and then found himself being approached by gallery manager Peter Webster.

The exhibition features some 30 oils, watercolours, charcoals and drawings mostly with a cricketing theme. Several have never been displayed before and four are being borrowed from his parents' house "while they're on holiday".

The 26-year-old has been playing cricket professionally for five years and rediscovered his artistic skills during the moments when he was off the field.

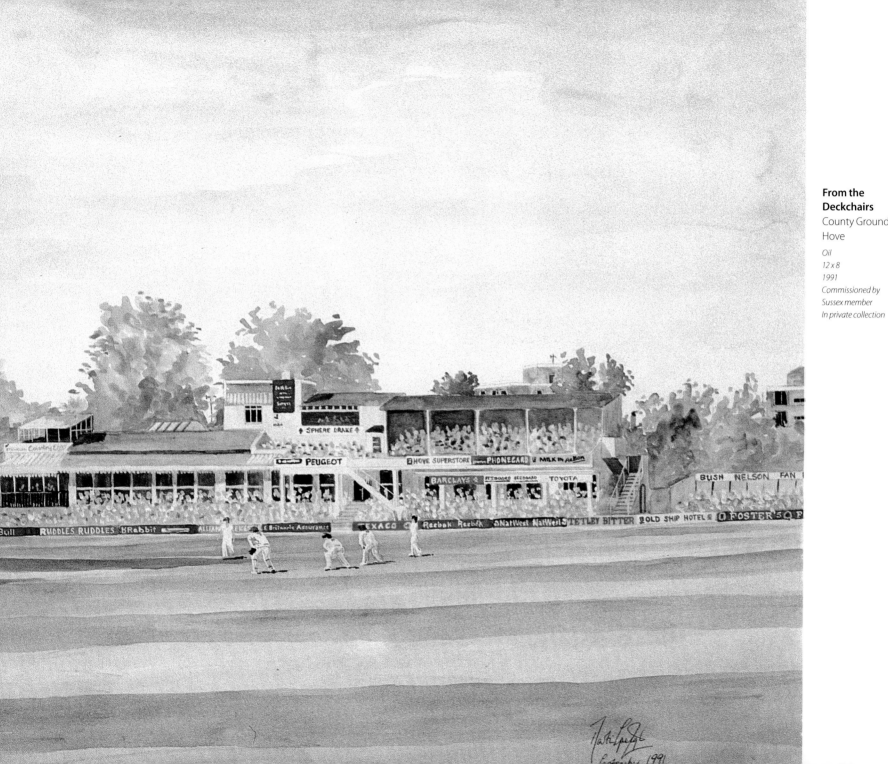

**From the Deckchairs**
County Ground,
Hove

*Oil*
*12 x 8*
*1991*
*Commissioned by*
*Sussex member*
*In private collection*

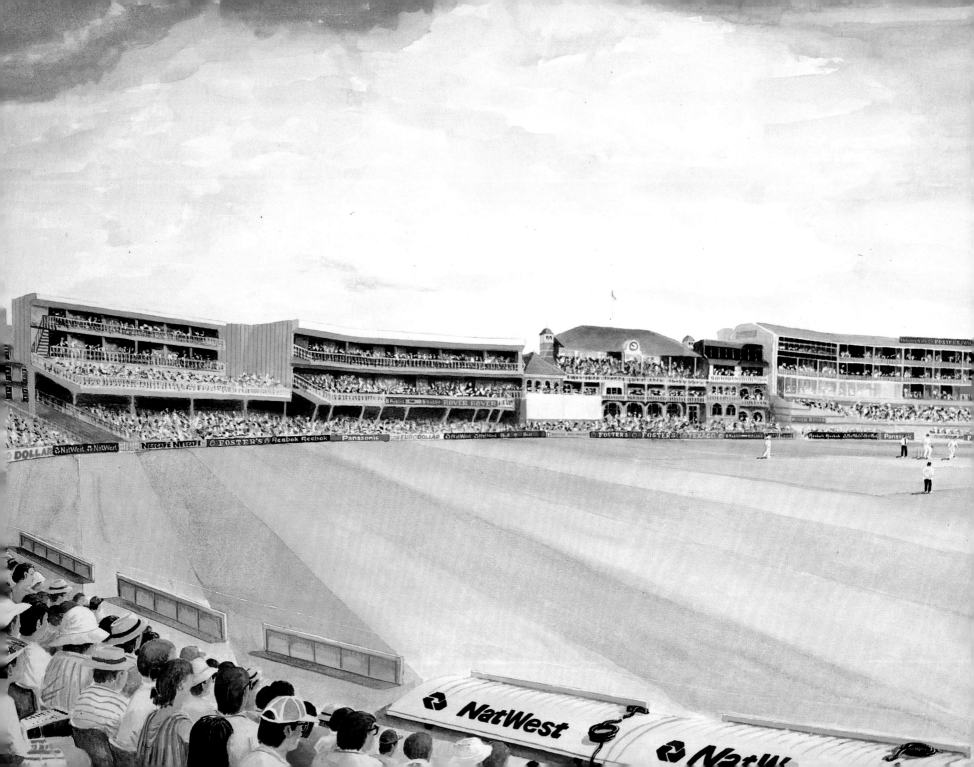

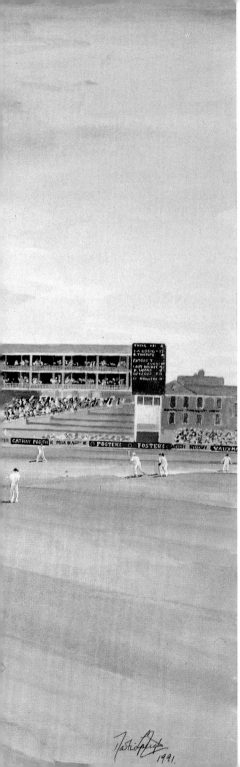

THE OVAL IS A CAVERNOUS GROUND AND THE only way to capture it in a painting is to take a broad sweep of the imposing stands. It is not as aesthetically appealing as, say, Lord's for instance but I was glad of the opportunity to paint it for Ian Greig's Benefit in 1991. The original painting was purchased by Fosters.

The Oval has not always been a happy hunting ground for Sussex but in 1994 we enjoyed a crushing championship victory over Surrey before lunch on the third day. It was exhilarating cricket with a relentless fall of Surrey wickets and I look forward to my next visit to this imposing arena.

**The Foster's Oval**

*Watercolour*
*24 x 18*
*1991*
*Commissioned for Ian*
*Greig's Benefit*
*In private collection*

## Have bat will travel

FIFTEEN year old Martin Speight is off to Sri Lanka in December on a three week cricket tour.

Martin, a wicket-keeper batsman, has been selected for the South of England under 17 squad.

He has been playing for his local team, Keymer and Hassocks, for the last five years.

A day boy at Hurstpierpoint College, Martin won a sports scholarship and is a member of the college first eleven.

Martin, whose family are hoping to get him sponsorship for the Sri Lankan tour, has played for Sussex Colts and Sussex schools.

His great ambition is to play for the full Sussex side, and Martin is currently waiting to hear if he has been chosen for the England under 15 after attending coaching courses.

AT THE AGE OF 18 I CAPTAINED HURSTPIERPOINT College on a cricket tour to India where we played 15 matches in four weeks. It was an eventful tour for many reasons, not least the fact that our visas were only issued two days prior to departure. In our final match, against Rajkumar College, we played for the Silver Elephant trophy, fittingly donated by the Jam Saheb of Jamnagar, great nephew of the immortal Ranjitsinhji. I scored 212 not out in an innings which lasted five hours and Hurstpierpoint won the trophy. Having seen the splendour of the Indian Palace, one of three in Jamnagar, it was just a matter of time before I sketched it and the drawing is now a tangible reminder of a truly memorable tour.

**Indian Palace**
Jamnagar, India

*Pencil*
*10 x 8*
*1986*
*In private collection*

M.P.Speight - The Guesthouse, Jamnagar

IN 1987 I FINALLY MADE IT TO SRI LANKA ON tour with England Young Cricketers, as a wicket-keeper batsman. Five years earlier, I had been ready to tour with the South of England Under-17 squad but the tour was cancelled due to political turbulence inside Sri Lanka.

Although we won only one game in a five-week tour, we drew six and gained invaluable experience. Mike Atherton was captain and amongst the many talented players on the tour were future Test players in Nasser Hussain, Mark Crawley, Mark Ramprakash and Martin Bicknell. We played in front of huge crowds, 47000 at Khettarama, and the international matches were given ball-by-ball radio coverage.

It was an education to play on all four Test grounds, including Colombo Cricket Club where play was interrupted by an iguana lizard crossing the outfield! Sri Lanka is an exotic country and the cricket grounds are a complete contrast to those we are used to playing at in England. I made sure that I took plenty of photographs so I would be able to paint the grounds later.

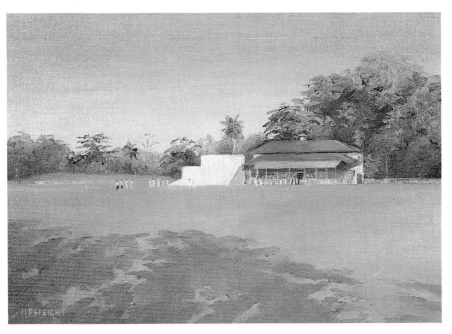

*Left to right:*
**Colombo**
**Nuwara Eliya**
**Kandy**
Sri Lanka
*Oil*
*14 x 10*
*1993*
*Martin Speight collection*

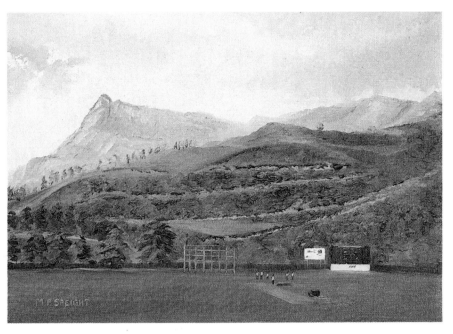

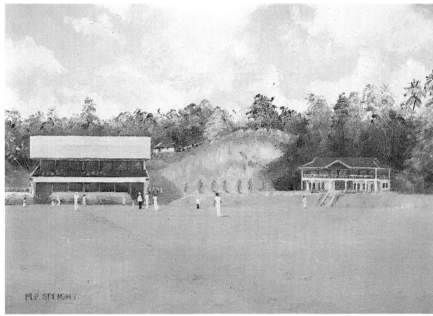

WINTER CAN BE AN AWKWARD TIME FOR COUNTY professionals in England but I have been lucky enough to spend four English winters playing and coaching in New Zealand. I first went to New Zealand in the winter of 1989/90 as club professional for Karori and a guest of the Wellington Cricket Federation. During my stay at Karori I was commissioned to paint a watercolour of the Basin Reserve during the 1992 World Cup.

It is a beautiful country and the cricket grounds are a joy to paint, so I was delighted to be able to return to New Zealand for three further English winters to play for the Wellington club University Backbencher and represent Wellington in the Shell Shield competition.

## Matches give Emerging Players chance to shine

WELLINGTON'S first class cricketers of the future get their chance to make an early impression on selectors over the next week.

Two games unusual on the first class programme have been scheduled for a team of Wellington Emerging Players.

The first will be a three-day match at the Basin Reserve starting on Sunday, against the New Zealand Youth team which is touring the country as part of the Brierley Youth Development programme.

The second game, against the touring Australian Cricket Academy team, starts at Kelburn Park on Thursday.

Both matches are important. The New Zealand Youth team is continues to show it is the nursery of future New Zealand representatives. While it does not have the resources of the Australian Academy, it nevertheless provides the best available training on New Zealand funding.

The second clash with the Academy team will pit the Wellington side against a potentially stronger op-

ponent which is on the verge of making a big impact in Australian cricket.

However the youth development schemes in both countries do not always catch the best players and it is with this in mind that the Wellington players have their chance to impress.

The squad is: Phil Barton, Mark Lane, Ross Verry (captain), Darren Sears, Stephen Mather, Martin Speight, Andrew Cavell, Glen Jonas, Doug Pollock, Tim Boyer, Scot McMahon, Mark Coles.

Several of the players have been prominent in age group cricket in New Zealand and there is every hint of the teams in both games being well-matched.

Sears has been prominent at national level in his winter sport of table tennis, and as a left-arm spinner he was a member of the New Zealand development squad.

Mather had a good season last year at age group level while Lane and Speight had good seasons with Wellington B this year. Speight made it through to first class play for Wellington during the season.

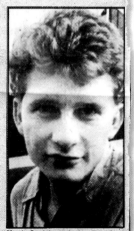

**Martin Speight – playing first class for Wellington this season.**

**Basin Reserve**
Wellington,
New Zealand

*Watercolour*
*18 x 12*
*1992*
*Commissioned for 1992*
*World Cup by Wellington*
*Cricket Association*
*In private collection in*
*New Zealand*

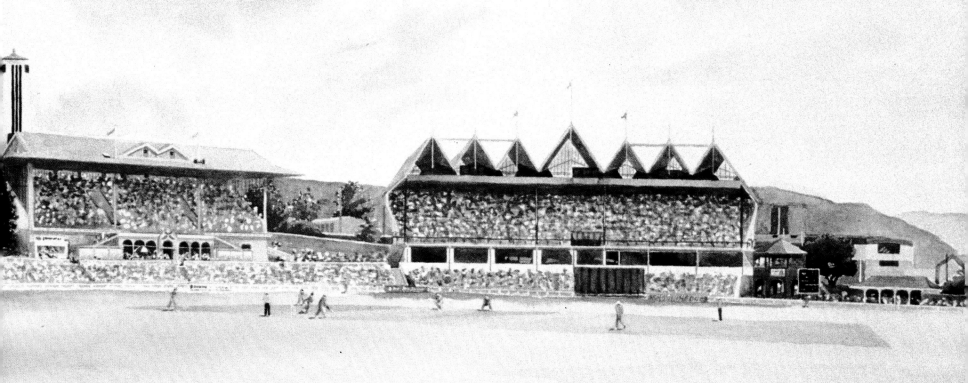

December 1991.

# Karori cricket has professional for season

Karori cricket players have been lucky this season to have the services of English professional Martin Speight.

Mr Speight is a guest of the Wellington Cricket Federation and will be based at the Karori Cricket Club until the end of March.

Mr Speight, 22, is the first player to come to New Zealand as part of a cricket exchange between the English countyside Sussex and the Wellington Federation.

He says the experience is great as he is not only playing cricket for the Karori seniors but is coaching young people.

He feels Wellington cricket is very healthy but often the local wickets are not up to the standard of players.

He says one of the main problems in New Zealand is that wickets are not covered, which makes it hard to keep them in top order.

In England all good clubs cover the wicket, he says.

However, Mr Speight says New Zealand initiatives like Kiwi cricket are great for the game as they encourage young people to play.

Mr Speight completed a BA honours at Durham University before turning to his professional career last year.

Normally a batsman, Mr Speight also stands in as wicket keeper when needed.

Being a professional in England means work for only six months of the year so many players go to other countries for the other six months.

Mr Speight is hoping to do this again next season.

If his cricket career goes to plan he hopes to become a senior cap for Sussex and ultimately to play test cricket for England.

In the mean time he is getting as much experience as he can and keeping fit by running and playing hockey and squash.

Mr Speight says, contrary to public impressions that English cricket is in a rut, the overall game in England is still very healthy.

He blames recent losses to Australia and the West Indies on the selection process.

"Not all the best players are being chosen because we don't have selectors with their fingers on the pulse.

"Ideally selectors should be recently retired professionals," he says.

Since coming to New Zealand in October last year, Mr Speight has been able to travel around the country. He says if cricket in England doesn't work out we may find him back here again.

Martin Speight, Karori's very own professional cricketer.

# One wrong turn leaves players with red faces

ONE wrong turn in Palmerston North spelled trouble and red faces for four members of the Wellington Emerging Players' cricket side.

Due in New Plymouth yesterday morning for a two-day match against Taranaki, they left their Palmerston North motel with instructions on how to get to New Plymouth.

However, a right turn instead of a left turn in the city saw the car-load heading for Hawke's Bay. Through the Manawatu Gorge they went, driven by English professional Martin Speight who could have been excused for not knowing the way.

Through Woodville and Dannevirke they travelled. A petrol stop and a hunger for pies saw the group pull in at Waipukurau.

The garage attendant was asked just how far it was to New Plymouth and that was when the faux pas was realised.

Speight and his three travelling companions, Mark Lane, Mike Coles and Hamish Shearer, did a quick turn around and headed for New Plymouth. A phone call from Wanganui only 15 minutes before start time of the match informed their teammates of their predicament.

With only seven players in New Plymouth, team captain Kerry Marshall "negotiated" the toss with Taranaki captain Brian Richards and Taranaki went into the field and Wellington into bat.

Wellington finished the day with 193 and Taranaki, at stumps, had reached 117 for 3. The match continues today.
— NZPA

# Back for hat-trick

Free-scoring English county batsman Martin Speight has returned for his third consecutive season with Wellington club University Backbencher after coming close to representing his country

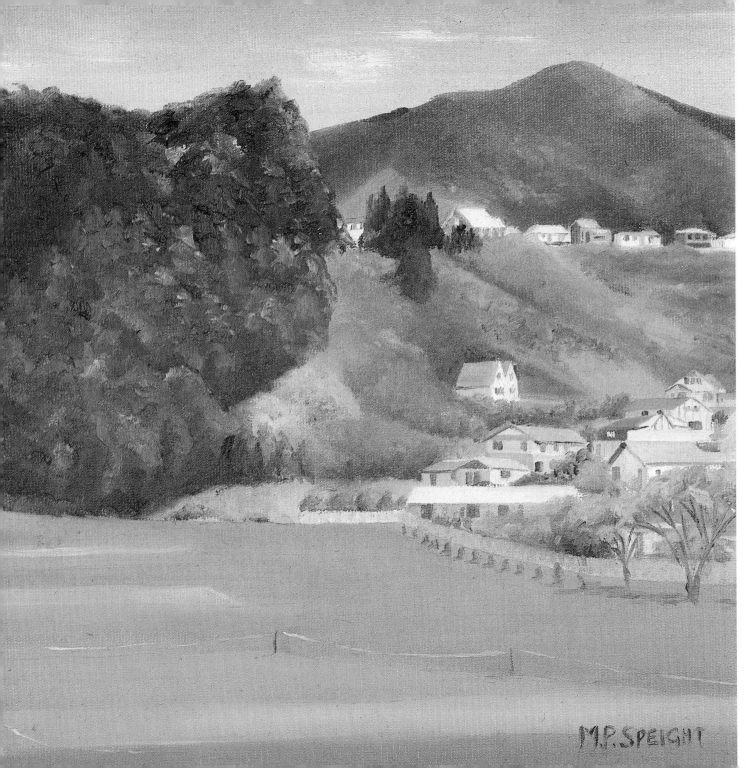

M.P.SPEIGHT

**Karori Park**
Wellington,
New Zealand

*Oil*
*14 x 10*
*1993*
*Martin Speight collection*

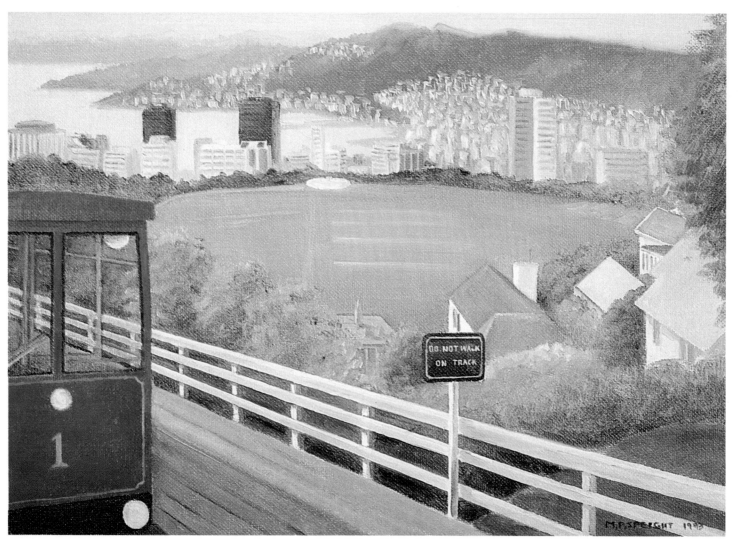

**Kelburn Park**
Wellington,
New Zealand

*Oil*
*14 x 10*
*1993*
*Commissioned by*
*Captain of University*
*Backbenchers*
*In private collection in*
*New Zealand*

**Pukekura Park**
New Plymouth,
New Zealand

*Oil*
*12 x 10*
*1993*
*In private collection*

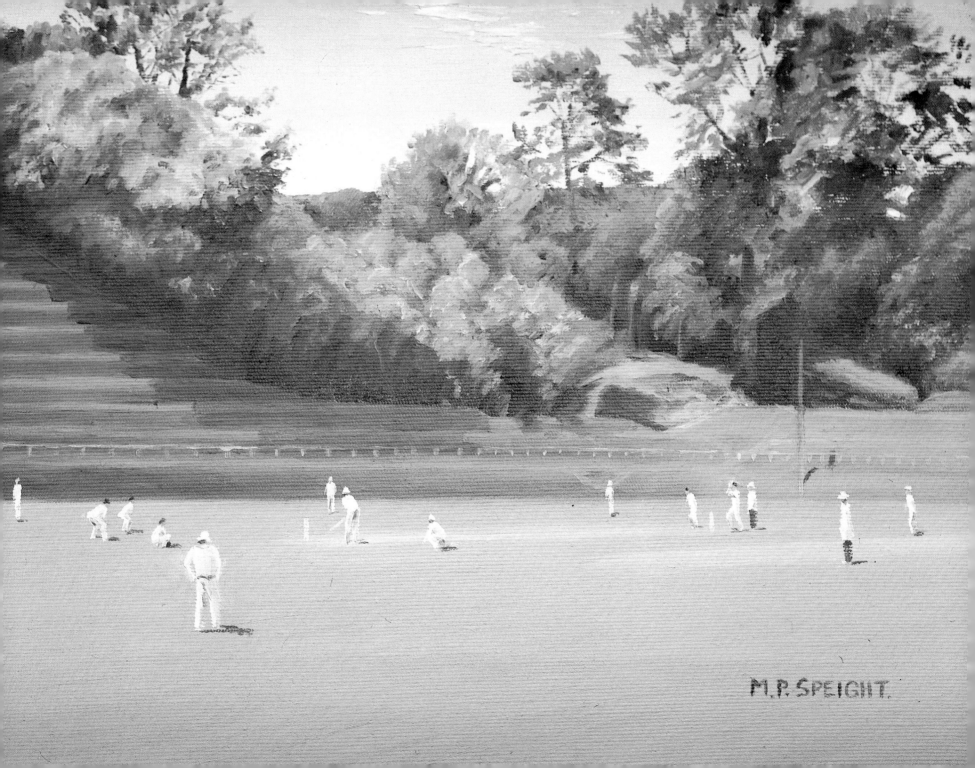

M.P.SPEIGHT.

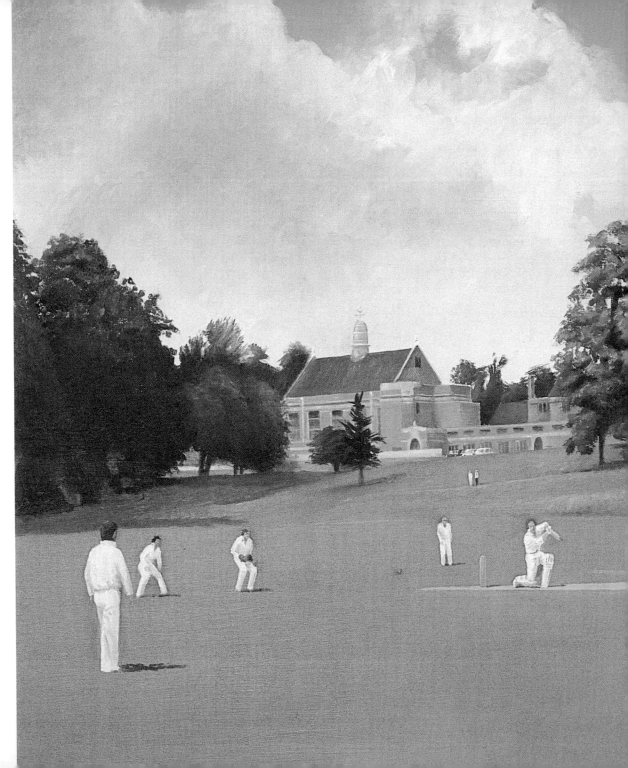

LANCING, WHITGIFT AND CHELTENHAM ARE three favourite college grounds of mine. I played schools cricket at Whitgift and Lancing and have played at Cheltenham for Sussex.

The Whitgift oil painting was commissioned by the Croydon school to commemorate their 400th anniversary, in 1995. Lancing and Cheltenham were both challenging to paint. The Lancing College chapel is a beautiful and imposing building which dominates the ground and I decided that a watercolour was the best treatment. Given the superb symmetry and intricate architectural splendour of Cheltenham College it could only be drawn in pencil, and it seemed apt to deliberately leave on the rule I used to achieve the correct spacing and perspective. I find the result very satisfying.

**Whitgift School**

*Oil*
*48 x 24*
*1995*
*Commissioned for*
*400th Anniversary*

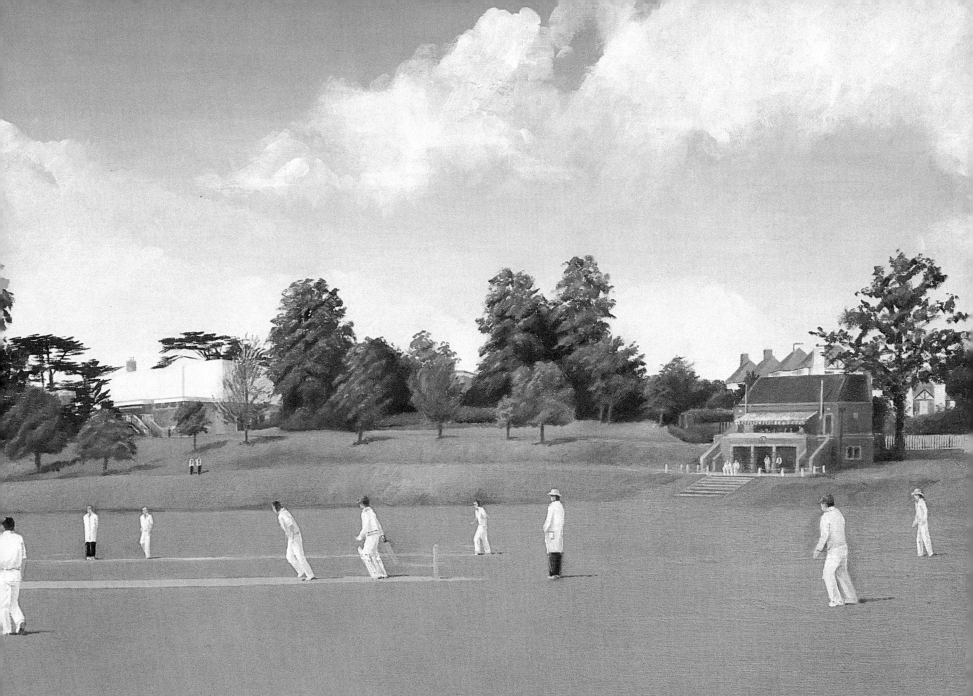

M.P.SPEIGHT - 1995

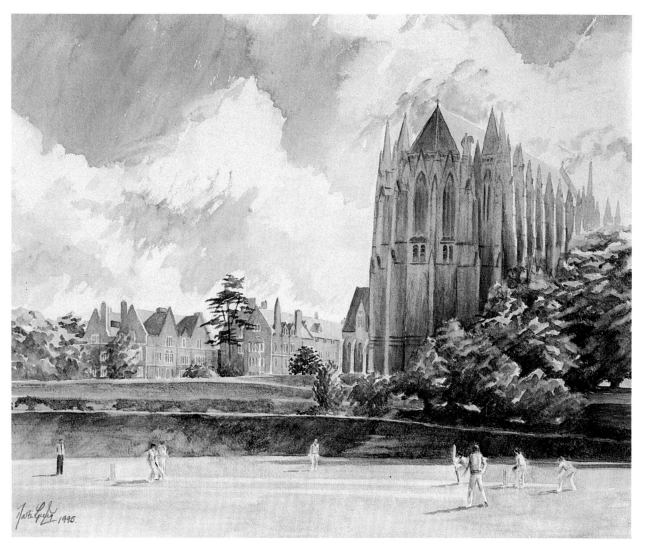

**Lancing College**

*Watercolour*
*16 x 12*
*1995*
*Commissioned*
*In private collection*

**Cheltenham College**

*Pencil*
*18 x 12*
*1993*
*In private collection*

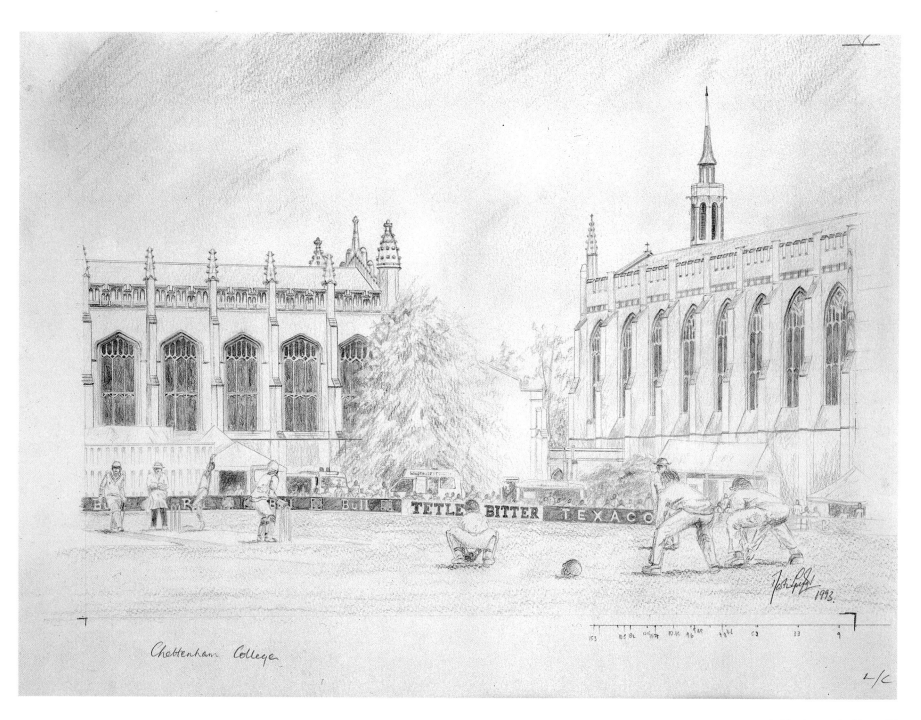

Cheltenham College

**STUDENT SPORT**

# Universities draw on Durham's strength

### By Mark Herbert

The contention that **Durham** is the country's strongest cricketing university gained weight this week following the first win by Combined Universities, over Surrey on Wednesday.

Four of the student team — Speight, Boiling, Hussain and Longley — came from Durham and a fifth, O'Gorman, a Derbyshire county player, was in the squad of 13. The feeling is that this year's may be the last, and best of the vintage sides produced in the 1980s.

For all the Test and county players the university has groomed, however, Durham's record is patchy. They have won three Universities Athletic Union (UAU) titles in the last 10 years — a record matched by **Exeter** — and last season lost in the final to give **Swansea** their first championship.

The circumstances — injuries

beyond our
ing

ON LEAVING HURSTPIERPOINT College my academic and cricketing education continued at Durham University which I attended from 1986 to 1989.

I had earlier applied to read History at Keble College Oxford but whereas postgraduates who excel in rugby and rowing seem to enjoy an easier passage to Oxbridge, they turned me down.

After a fantastic three years at Durham I can have no regrets at going there. I played in three UAU finals and kept wicket for the Combined Universities XI who enjoyed unprecedented success. In 1989 we defeated Surrey and

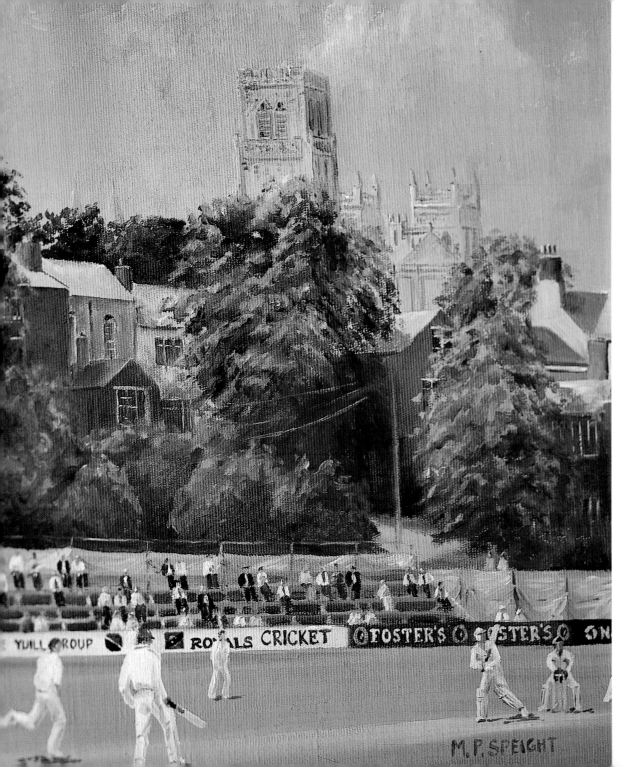

Worcestershire, then lost to Somerset in the quarter-finals of the Benson & Hedges Cup.

The change in composition of the Combined Universities side ended the Oxbridge closed shop and the results spoke for themselves. I don't believe that continued privileged status for Oxford and Cambridge is viable, ☞

**The Racecourse Ground**
Durham

*Oil*
*10 x 12*
*1994*
*In private collection*

## Durham give Cambridge a hiding

**By Charles Randall**

CAMBRIDGE UNIVERSITY suffered a humiliating 134-run defeat in a 55-over match at Durham University on Saturday.

It put some perspective on the strength of a vintage Durham side, who defend their UAU title against Exeter at Bourneville tomorrow.

As for Cambridge, the wee[...] [...] actin[...]

## Students learn the hard way

THE amateur cricketers from Combined Universities face an impossible task at Bristol today.

They want 114 to beat Gloucestershire with only 14 overs to go and three wickets in hand.

The rain gave them no more than a reprieve into a second day but at times they gave a lesson in ap[...]tion [...] make the game their living.

especially when their selection policy is not geared to accepting emerging cricketers. Playing for Combined Universities allowed me to renew acquaintance with many of my teammates from the England Under-19 tour to Sri Lanka and the fact that we had played together before clearly contributed to our success.

Durham had more to offer than cricket. The river and mill is an attractive scene and I relished the opportunity to paint it in oils,

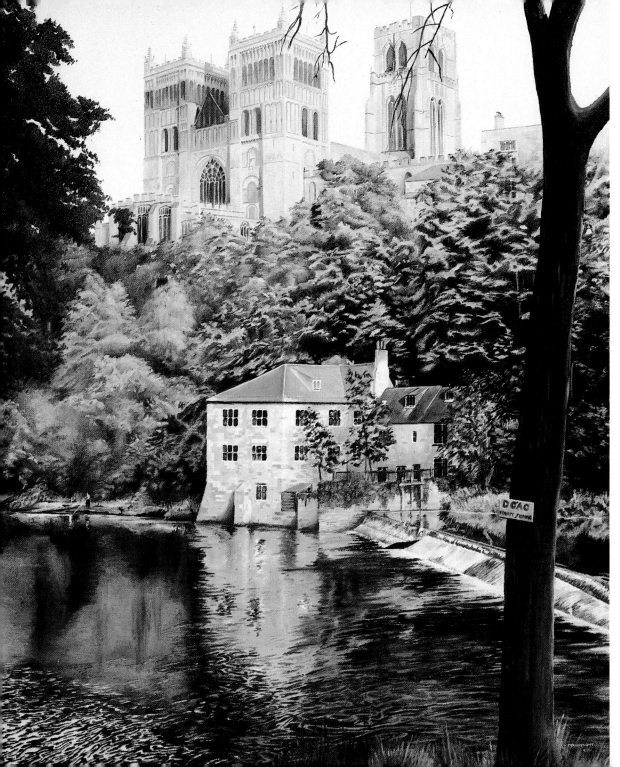

especially with the cathedral looming in the background. I am looking forward to playing at Durham's new ground at Chester-le-Street and will make sure I take my paint brush as well as my bat when I return to Durham.

**Durham
Cathedral and
Fulling Mill**

*Oil*
*14 x 18*
*1988*
*In private collection*

PRIORY MEADOW IS A HISTORICAL CRICKET ground and I was determined to capture it in a painting before the contentious redevelopment took place. Cricket watchers and players alike become emotionally attached to cricket grounds, and looking at the unique vista of Hastings it is unbelievable to think that plans to turn it into a car park and superstore take precedence over its use as a venue for first-class cricket. The buildings surrounding the ground may conspire to give it a hotch-potch appearance, but it has a charm of its own.

I scored my maiden first-class fifty at Priory Meadow against Kent during my second year at Durham University when I was only able to play for Sussex during vacation. It is not necessarily a proud claim to say that you played in the last ever first-class match at Hastings.

## Middlesex deliver last rites at Priory Meadow's wake

**By Doug Ibbotson at Hastings**

THERE were a few forlorn disciples at Hastings yesterday who cared deeply that, short of divine intervention, they were watching the final day of the last first-class match at Priory Meadow.

There were those, including a female video camera person, who on behalf of their media employers were watching cricket at Hastings — or anywhere else — for the first time.

*Middlesex beat Sussex by nine wickets*

**Priory Meadow**
Hastings

*Watercolour*
*16 x 12*
*1994*
*In private collection*

*Over page:*
**First Ball of the Day**
County Ground,
Hove

*Oil*
*36 x 18*
*1995*
*Commissioned*
*In private collection*

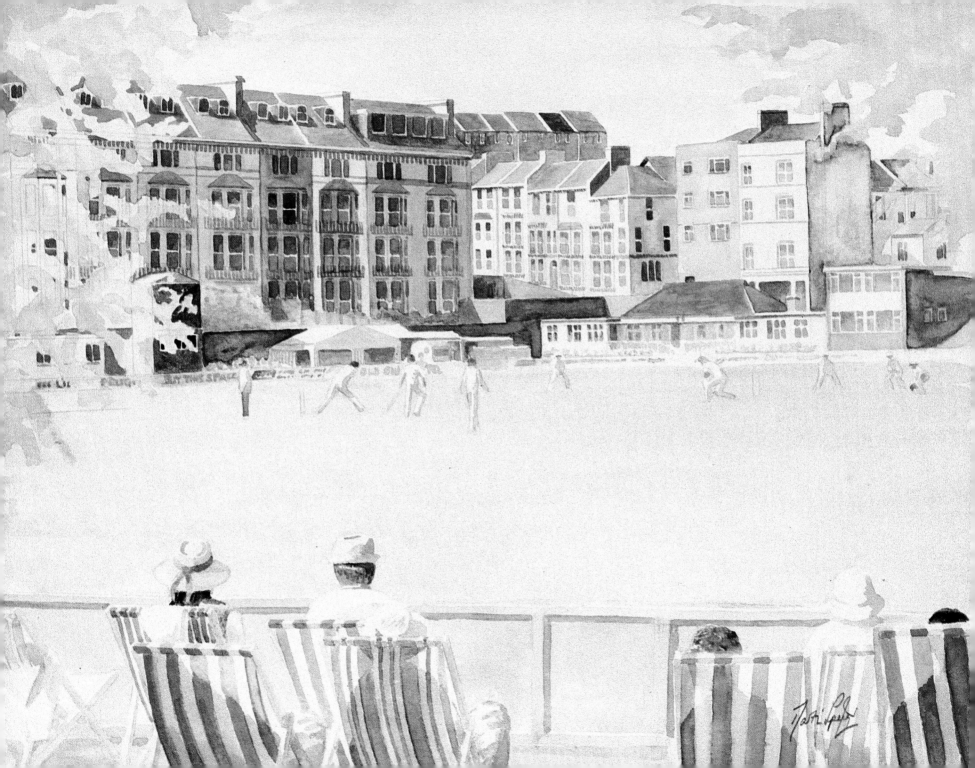

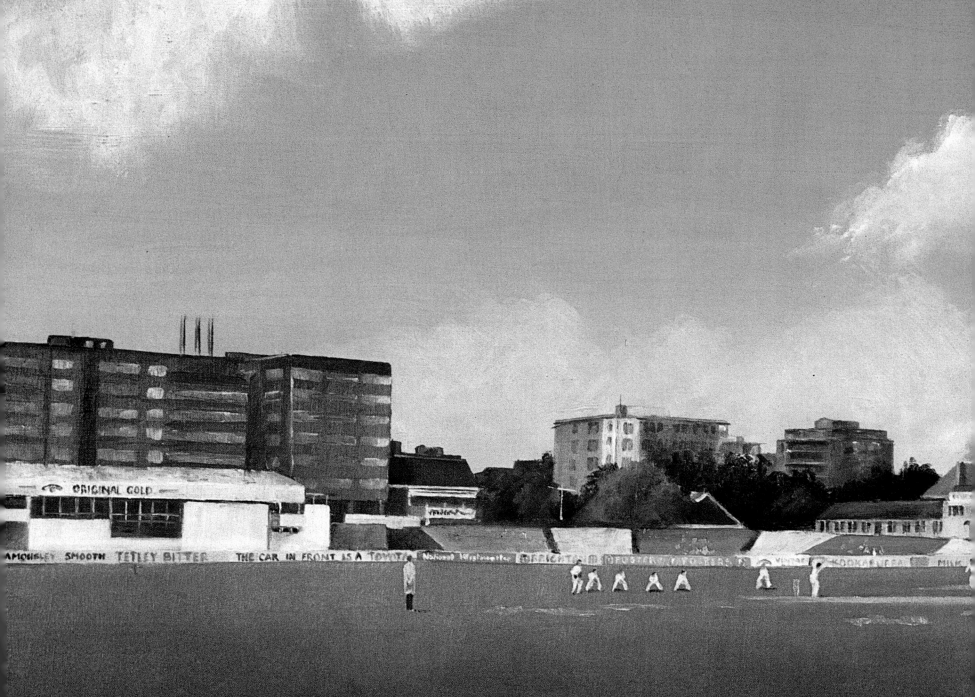

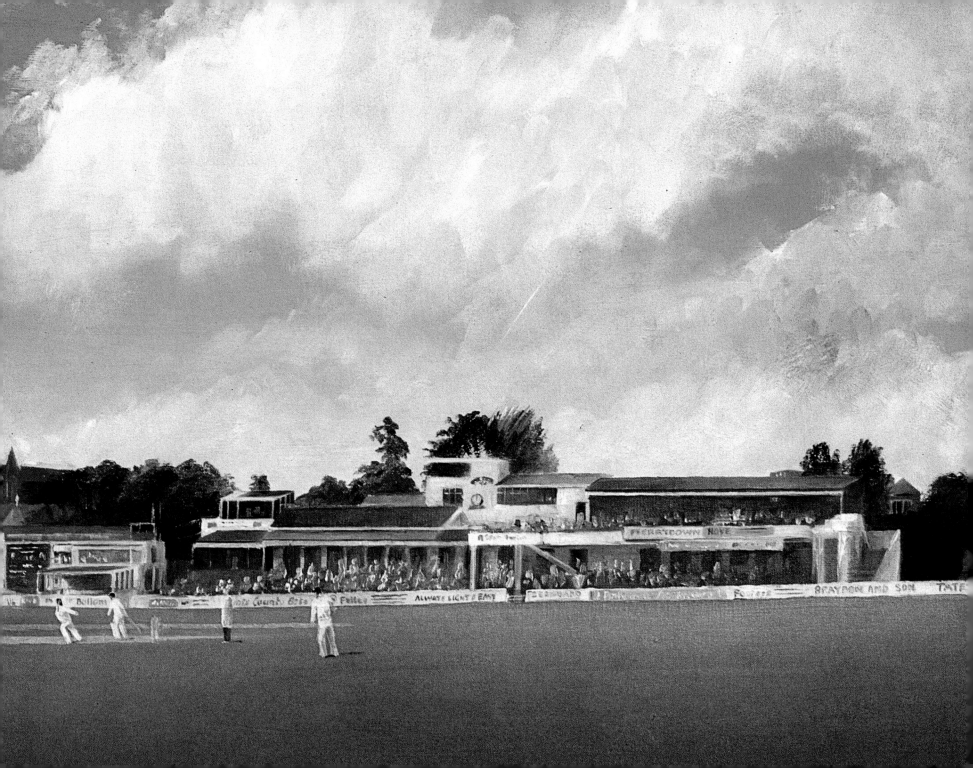

I HAVE NOW PRODUCED MANY PAINTINGS FOR players' Benefits but Tony 'Lester' Pigott started the ball rolling when he noticed me sketching the Town Hall overlooking the Saffrons. He asked me for a painting to support his Benefit and I later had an opportunity to do a charcoal of Lester when a Sussex member asked for a drawing to give as a Christmas present. Similar portraits of Colin Wells, for his Benefit brochure, and Franklyn Stephenson followed.

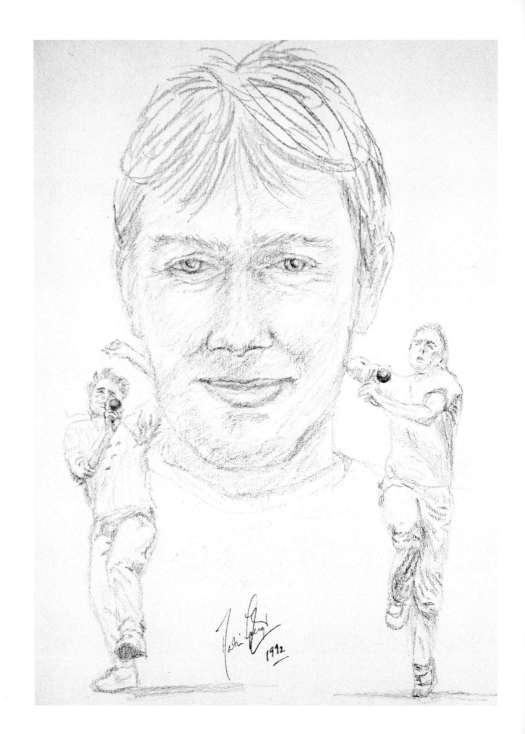

**Lester**
Tony Pigott

*Pencil*
*12 x 16*
*1992*
*Commissioned by*
*Sussex member*
*In private collection*

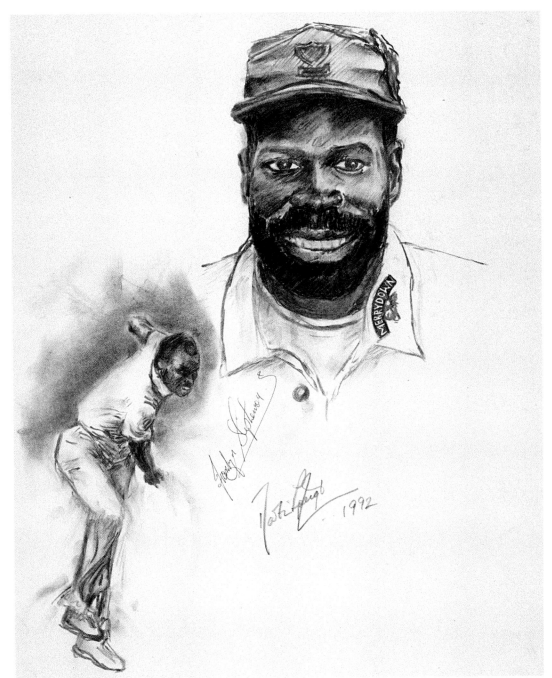

**Frankie**
Franklyn
Stephenson

*Charcoal*
*12 x 16*
*1992*
*In private collection*

# DOUGIE

**Dougie**
Colin Wells

*Pencil*
*12 x 16*
*1993*
*Commissioned for Colin*
*Wells' Benefit*
*In private collection*

THE SAFFRONS HAS ALWAYS BEEN A FAVOURITE
ground of mine as I always get runs there. I hit
a career-best 184 against Notts at Eastbourne,
as well as 179 the year before. It's a lovely
ground to play at and like Horsham, it is a real
home from home.

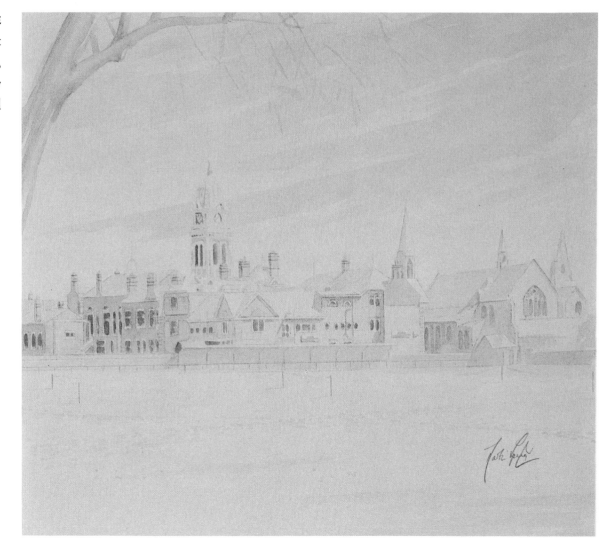

**Eastbourne
Under Snow**
The Saffrons,
Eastbourne

*Watercolour*
*18 x 14*
*1994*
*In private collection*

# Young master Speight hits 184

THE scenery at The Saffrons evidently brings out the artist in Martin Speight.

The Sussex batsman hit a career-best 184 against Notts there yesterday.

His previous highest of 179 was scored on the same Eastbourne ground against Glamorgan a year ago.

"I certainly get some runs here," said Speight who, when he is not lifting a bat, is often picking up a paint brush.

"I have got two 88's and now two hundreds. I cannot put my finger on why. It's just luck I suppose."

Speigh...

SUSSEX'S uncapped opener, Martin Speight, could not have chosen a more opportune moment to score a championship-best 88 than against Leicestershire at The Saffrons yesterday.

Little has gone right for Speight since he scored 53 in his first championship innings of the season against Yorkshire at Middlesbrough last month.

His lean spell ended with what proved to be the backbone of Sussex's first innings total of 258. By the close Leicestershire had scored 44-0 off 20 overs.

# Speight's Saffrons artistry

**By Paul Newman at Eastbourne**

*Sussex (262) bt Notts (168) by 94 runs*

COPIES of a painting by artistic batsman Martin Speight of the Saffrons were on sale to the Sussex public yesterday. The only thing missing on canvas was the omnipresent sight of Speight himself scoring runs.

He was at it again at what must be one of his favourite venues, putting the game out of Nottinghamshire's reach and keeping Sussex in the Sunday League hunt with a dramatic opening flourish.

In the old Sunday games...

**The Saffrons**
Eastbourne

*Watercolour*
*18 x 12*
*1992*
*In private collection*

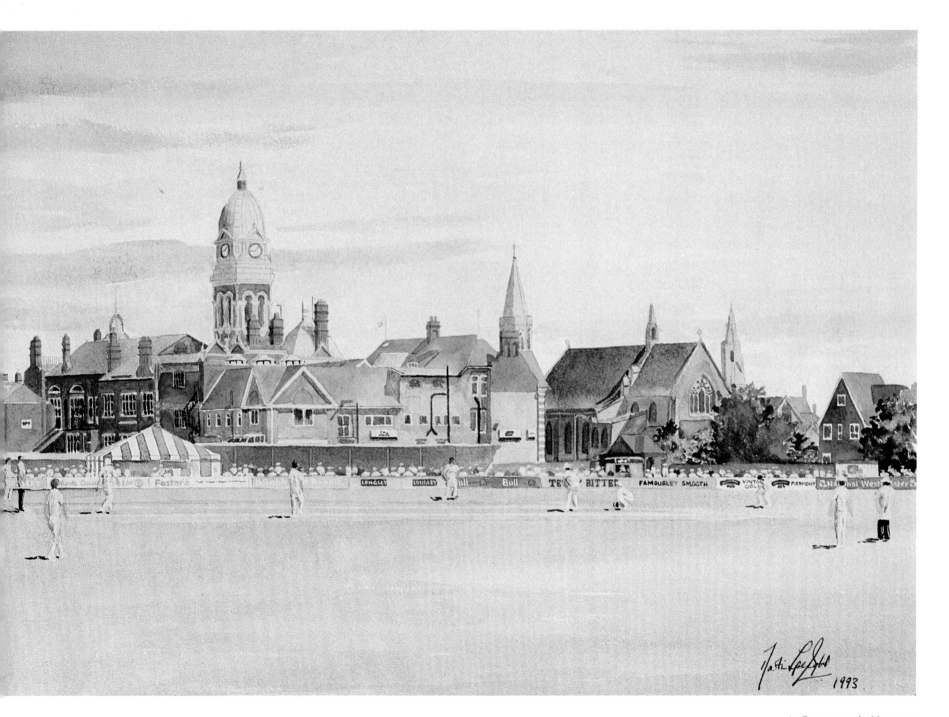

1993

## IAN BOTHAM AND SIR RICHARD HADLEE

THE JOY OF BEING A PROFESSIONAL CRICKETER IS one thing, but the thrill of playing with and against some of the contemporary giants of the game is something else. I've had the pleasure of watching Ian Botham go after a half-volley and nicking the ball to me behind the stumps. Like countless other batsmen all over the world I've been bowled by a classic delivery from Richard Hadlee. I've witnessed at first hand the brutal hitting and fearsome bowling of Wasim Akram. As a wide-eyed youngster I kept wicket to Imran and was amazed by the swing and dip of his bowling.

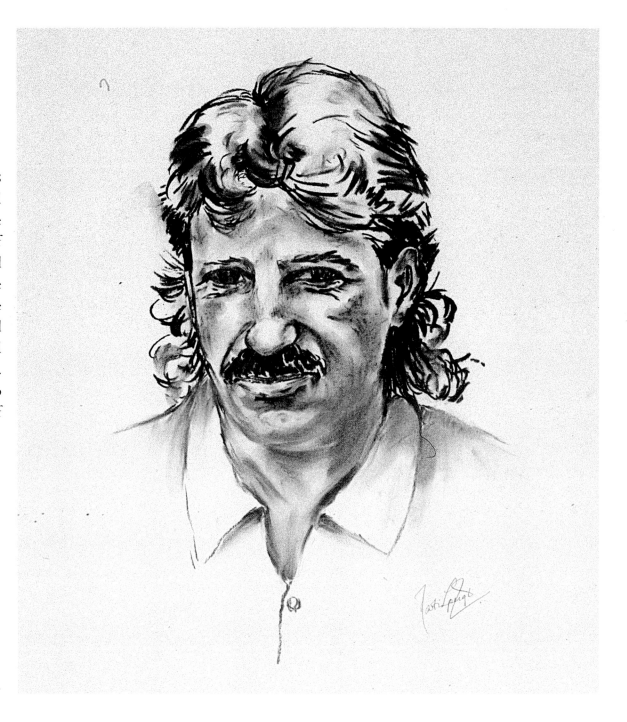

**Ian Botham**

*Charcoal*
*14 x 20*
*1993*
*Commissioned for Colin*
*Wells' Benefit*
*In private collection*

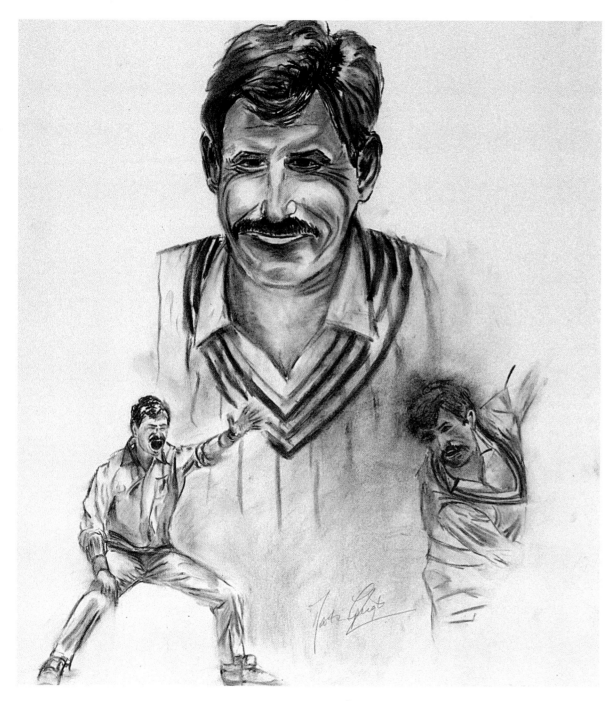

**Sir Richard
Hadlee**

*Charcoal*
*14 x 20*
*1993*
*Commissioned for Colin*
*Wells' Benefit*
*In private collection*

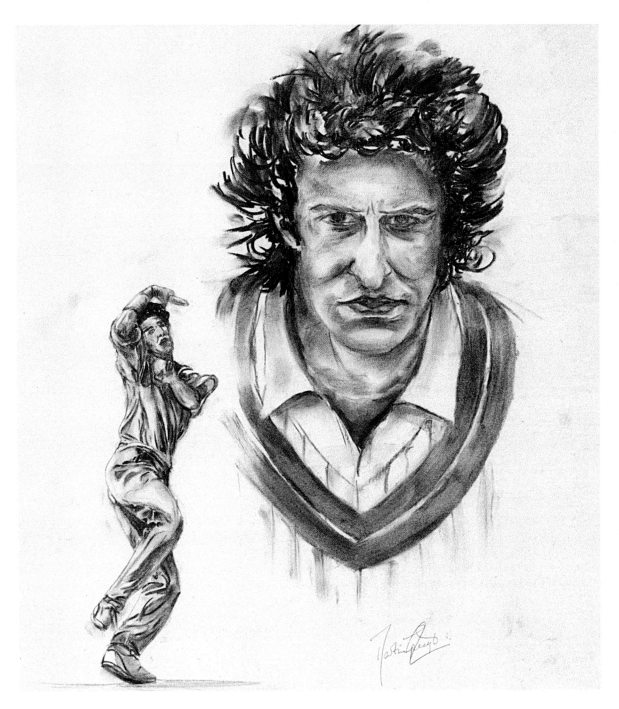

**Wasim Akram**
*Charcoal*
*14 x 20*
*1993*
*Commissioned for Colin*
*Wells' Benefit*
*In private collection*

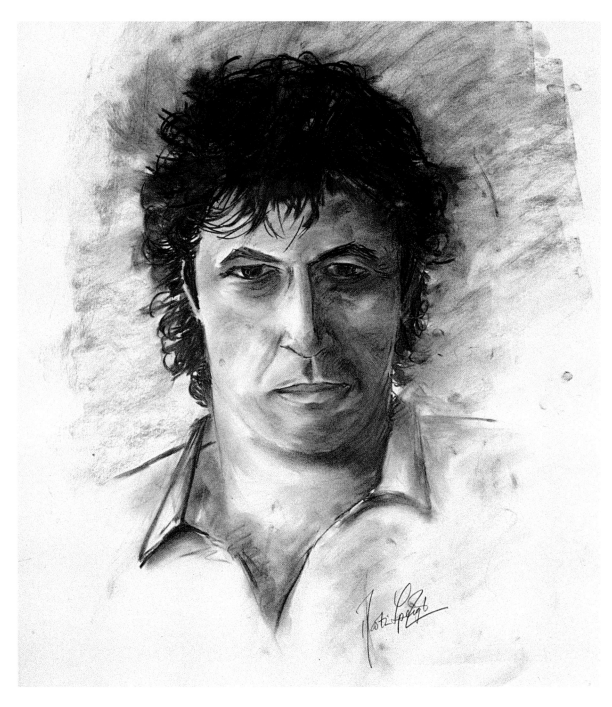

**Imran Khan**
*Charcoal*
*14 x 20*
*1993*
*Commissioned for Colin*
*Wells' Benefit*
*In private collection*

IN COUNTY CRICKET PLAYERS ARE ALWAYS looking for help and support in their Benefit year and I have been frequently called upon to produce a picture to be auctioned to raise funds for a fellow professional.

On this occasion, Derek Pringle approached me clutching what looked like a scrappy piece of paper. He handed the paper to me and asked could I do a portrait of the four people whose signatures he had collected on the sheet. On his cricket travels around the world he had collected four coveted autographs. I looked at the seemingly blank sheet and recognised the signatures of four sirs of cricket; Sir Donald Bradman, Sir Colin Cowdrey, Sir Garfield

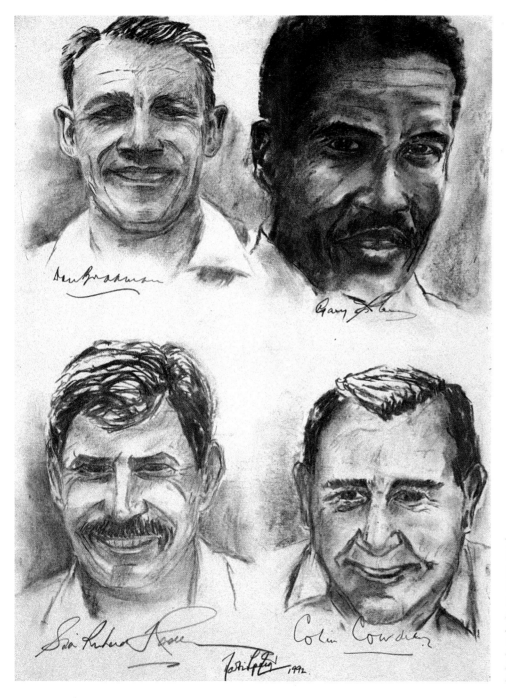

Sobers and Sir Richard Hadlee. By giving me the paper already signed he left me no room for error and I built up the portraits around the famous signatures.

My reward for this particular piece of artistry was a bottle of fine wine!

**THE FOUR SIRS**
**Sir Donald Bradman**
**Sir Garfield Sobers**
**Sir Richard Hadlee**
**Sir Colin Cowdrey**

*Charcoal*
*8 x 12*
*1992*
*Commissioned for Derek*
*Pringle's Benefit*
*In private collection*

IMAGINE THE SCENE; A PACKED LORD'S AND TWO of the greatest players the world has ever seen facing each other. Can you imagine Botham bowling to the greatest batsman the world has ever seen and striking that unmistakable pose in a vociferous appeal for leg-before? Would the ball have disappeared over the boundary? I was asked to interpret this fantasy scenario for a forthcoming publication entitled The Dream Ashes Test. The result is this watercolour and mixed media representation of a contest that would keep cricket followers talking for years!

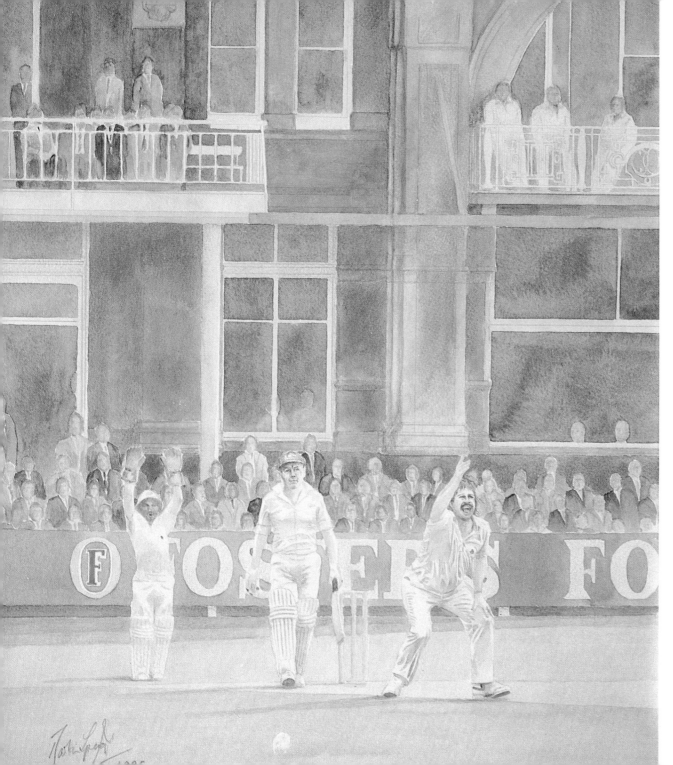

**The Dream
Ashes Test**
Botham appeals for
Bradman's wicket
at Lord's

*Watercolour/mixed media*
*18 x 14*
*1994*
*Commissioned by*
*Blandford Press for a*
*book cover*

THE CRICKET GROUND AT ARUNDEL CASTLE IS one of the most attractive settings in the world to play cricket and is famous throughout the cricket world as the location where touring sides play against Lavinia, Duchess of Norfolk's XI in their opening fixture. I have had the pleasure of playing for Lavinia's side four times, with mixed success. I scored a

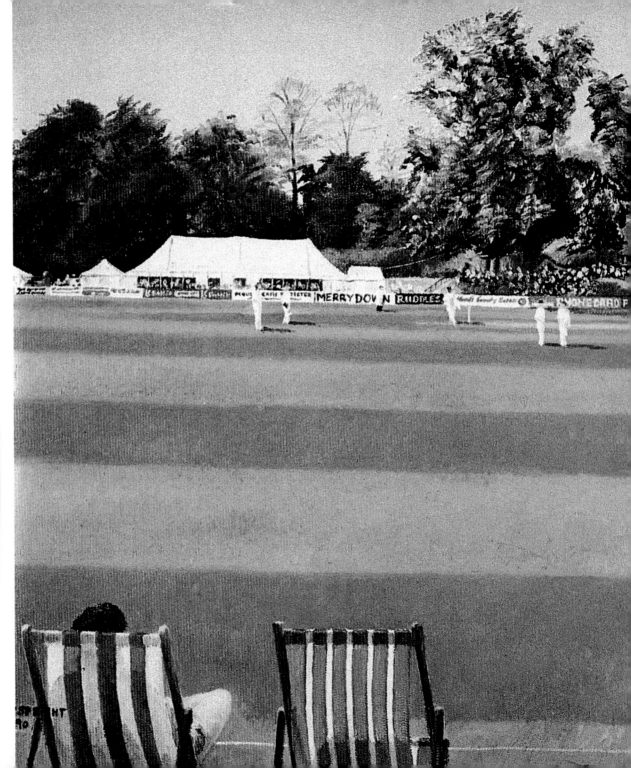

**24 EVENING ARGUS, Tues**

**Inside S**

# Speight faces Aussies

SUSSEX wicket-keeper Martin Speight and former Sussex spinner Chris Waller are in the Duchess of Norfolk's side to play Australia in a one-day match at Arundel on May 7.

**S**USSEX batsman Martin Speight is hoping to emulate England's deposed wicketkeeper Jack Russell both on and off the field.

Despite being denied the chance to don the gloves for Sussex by Peter Moores, Speight still hopes to emerge as a wicketkeeper-batsman, and like Russell he is also a talented artist.

Last year Speight's painting of the Arundel ground raised £1,200 towards Sussex Young Cricketers' tour to India, and this season his portrayal of the Hove and Chelmsford grounds is helping the benefit funds of Tony Pigott and David East.

Speight has already been commissioned by two of next year's beneficiaries with Sussex connections — Ian Greig and Bobby Parks — to paint the Oval and Southampton grounds.

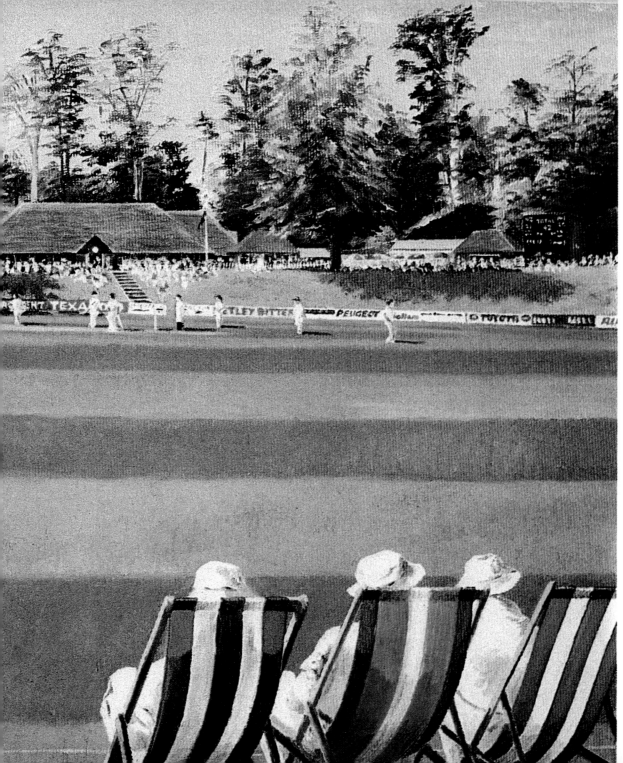

century versus MCC, opened the batting with Peter Willey against the touring Australians in 1991 and also achieved the dubious honour of making two ducks (one golden)!

No collection of cricket paintings would be complete without an image of Arundel. The original of this picture raised £1200 for the Sussex Young Cricketers' tour to India.

**Castle Park**
Arundel Castle

*Oil*
*14 x 12*
*1990*
*Commissioned to commemorate the 1st first-class match held at Arundel, Sussex v Hampshire*
*Auctioned and raised £1200 for Sussex Young Cricketers' tour to India*

CLIVE AND CATHY ROBERTS RUN THE OLD
Forge Restaurant and are imaginative supporters
of Sussex County Cricket Club. The Old Forge
Award is a monthly prize of dinner for two at
their classy restaurant in Storrington. It was a
pleasure to put together a montage which
included their renowned eating-house.

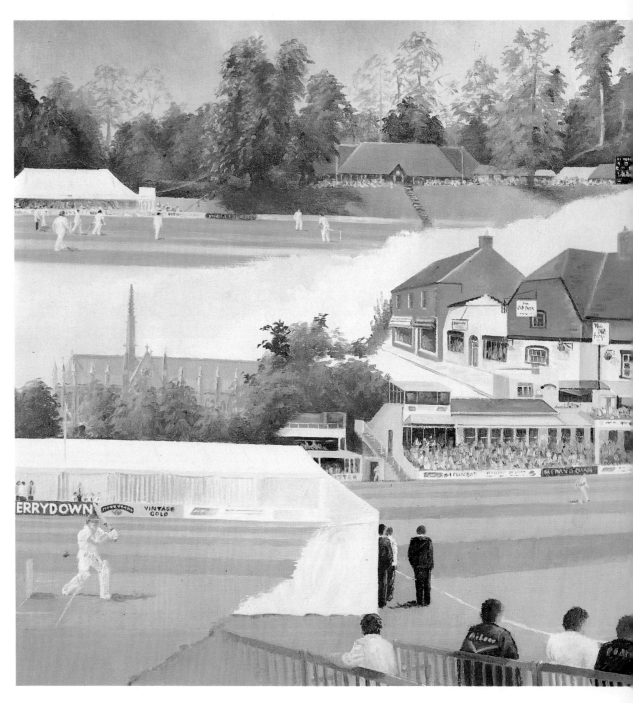

**Arundel Montage**

*Oil*
*24 x 18*
*1993*
*Commissioned by Sussex*
*member*
*In private collection*

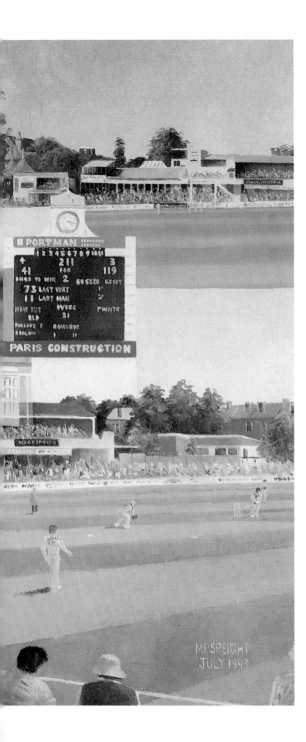

## BERT

ONE OF THE DELIGHTS OF PLAYING COUNTY cricket is the opportunity it affords to meet some of the fervent supporters that follow their county side through good times and bad. Individuals who appear to be always around the ground and seem to be known by everyone are part of the colourful scene that is county cricket. Every county has its characters and 'Bert' is remembered affectionately by all at Sussex.

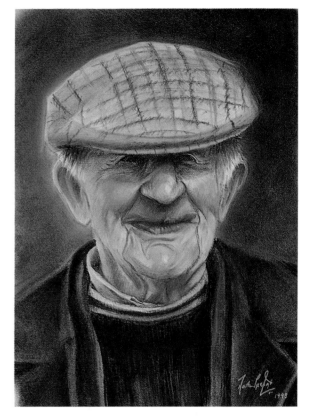

**Bert**
*Pastel*
*12 x 16*
*1994*
*Martin Speight collection*

THE NAT WEST TROPHY PROVIDES AN opportunity to visit some of the smaller cricket grounds and still play competitive cricket. The wickets can be less predictable than those at first-class venues and there are normally more trees around the boundary than there are spectators. I can easily find myself sizing up the ground and surroundings from the artist's perspective, as well as looking at the ground from a cricketer's point of view.

It's a surprise to many that there are actually grounds in Scotland and Ireland and I have been fortunate enough to play at both. They are lovely grounds, pleasant enough to lull you into a false sense of security by the tranquility of the surroundings. It is vital to remember that the cricket is still serious and in reality it can be nerve wracking playing at the smaller grounds as to lose to a non first-class team would lead to acute embarrassment on the county circuit.

Sussex almost lost to Scotland on one occasion and on our last visit to Edinburgh we played against a side which included Andy Goram, the Scotland footballer, in his last game of competitive cricket before joining Glasgow Rangers. It felt unreal playing cricket at Downpatrick against Ireland but the hospitality was fantastic and such visits make a welcome change to the normal routine of county games.

Lurgashall is another pretty small ground with an attractive backdrop for a painting and a terrific pub, Noah's Ark, at the edge of the ground. Although I've had the pleasure of capturing it on canvas, I've not yet played there.

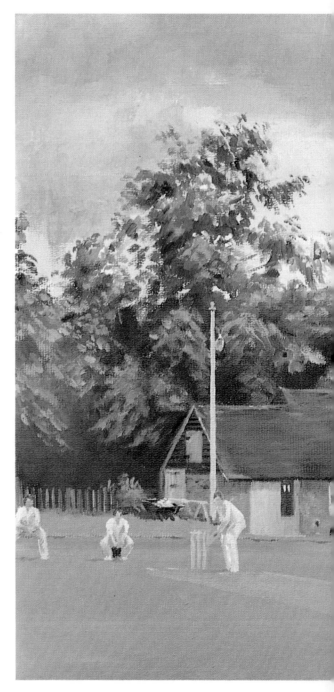

**Lurgashall**
*Oil*
*20 x 10*
*1994*
*Commissioned by*
*Sussex member*
*In private collection*

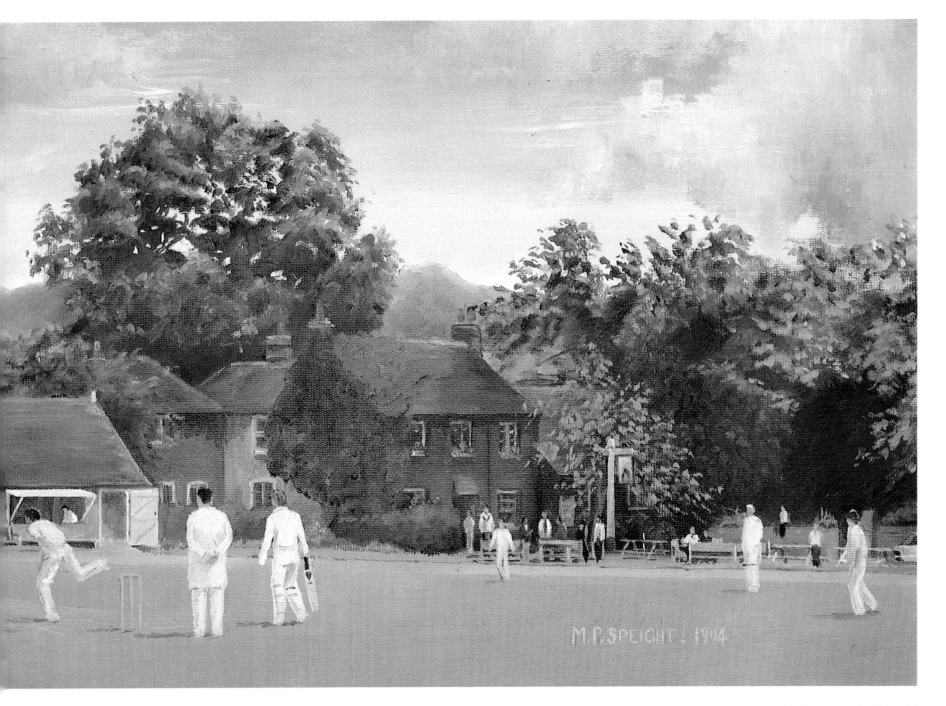

M.P.SPEIGHT. 1994

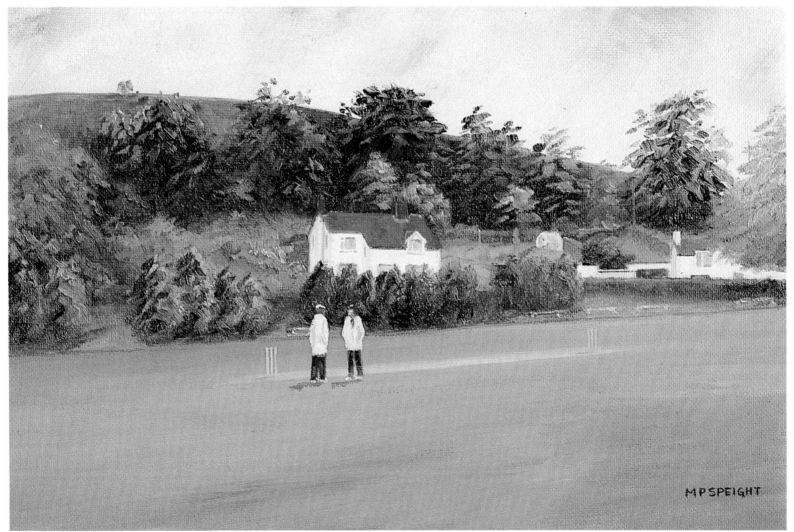

**Before Play**
Downpatrick

*Oil*
*16 x 12*
*1993*
*Painted for British Heart*
*Foudation Appeal*

*Right:*

**Lunchtime**
Myreside,
Edinburgh

*Oil*
*14 x 10*
*1993*
*Martin Speight collection*

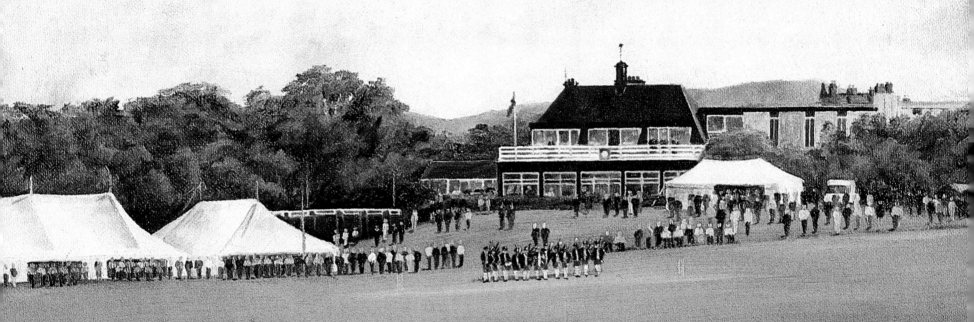

M.P. SPEIGHT

I WAS SURPRISED IT TOOK ME SO LONG TO GET around to painting the lovely ground at Cuckfield. It has a focal point which you can use to build the picture around and in my view works best as a watercolour. I've played there in benefit games, most recently with Jamie Hall who picked up an injury and was unable to play in the next senior game. Although that is one of the risks of playing other cricket in-between championship games, and you can't imagine many Premier League footballers being allowed to play full games between main fixtures, benefit games are an opportunity for a bit of fun and raise money at the same time. They also give me an opportunity to add more cricket grounds to my portfolio.

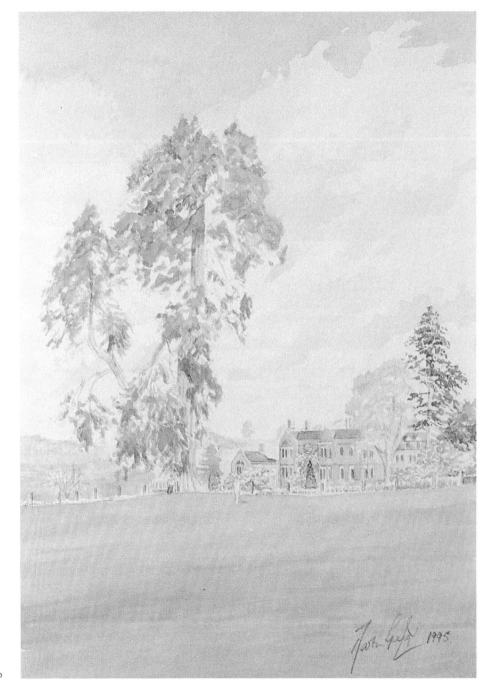

**Cuckfield**

*Watercolour*
*12 x 16*
*1995*
*Martin Speight collection*

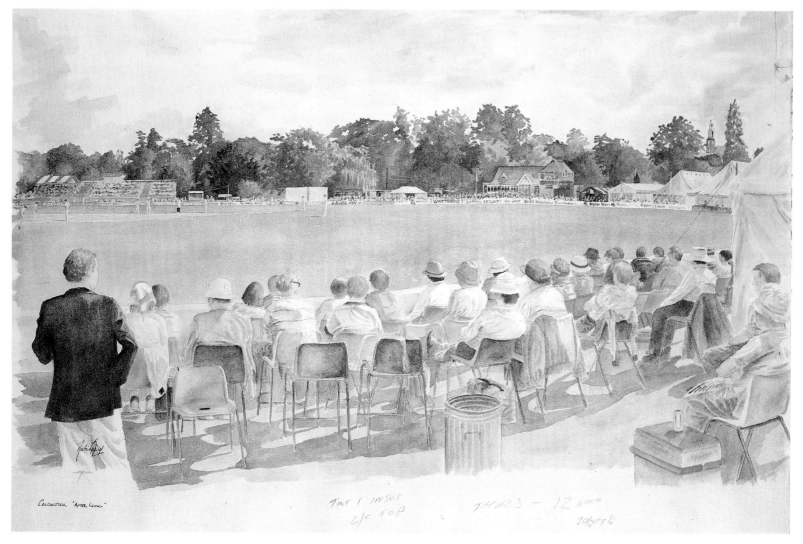

Colchester "After Lunch"

**Castle Park**
Colchester

*Watercolour*
*30 x 20*
*1992*
*Commissioned for Neil*
*Foster's Benefit*
*In private collection*

I VISITED BEACONSFIELD TO PLAY AGAINST Buckinghamshire in the Nat West Trophy and it provided my only experience of a 'streaker' (no Erica Roe, I can tell you) interrupting play! The naked miscreant was greeted by a witticism from Neil Lenham who said "I didn't know Dougie (Colin Wells) was twelfth man" much to the hilarity of the assembled players. The police quickly removed the offender and the game carried on as if nothing had happened, as only cricket can. Although I associate Beaconsfield with this event, I felt it had no place in the oil painting of the ground!

Colchester was another benefit painting, this time on behalf of Neil Foster and as yet I haven't played cricket there.

**Beaconsfield**
*Oil*
*18 x 12*
*1992*
*Painted for British Heart*
*Foundation Appeal*

M.P. SPEIGHT.

IMMEDIATELY AFTER STANDING IN FOR IAN Gould against Kent to make my first appearance for the senior side, I made my first-class debut at Taunton so it is a ground that features strongly in my memory.

In 1989 the Combined Universities reached the quarter finals of the B & H and after needing 30 runs off six overs lost to Somerset by only three runs. The match clashed with my finals at Durham but the university brought part of the exam forward 24 hours so I could play in the game. As a result, I was accompanied by a minder from the university to ensure that I wasn't tempted to pass on any exam tips to my colleagues yet to sit the exam.

Taunton is a lovely ground to paint and I don't know anyone who doesn't enjoy visiting and playing there.

## MARTIN MAKES COUNTY START

SUSSEX Young Cricketers captain Martin Speight, 18, made his debut for the full county side at Taunton on Wednesday, keeping wicket in place of the injured Ian Gould.

Speight substituted for Gould earlier in the week after scoring 37 on his second Sussex League appearance of the season for Worthing at Eastbourne on Saturday.

**County Ground
Taunton**

*Watercolour*
*16 x 12*
*1993*
*Martin Speight collection*

NORTHAMPTON ITSELF MIGHT BE AN unprepossessing place but Curtly Ambrose hurling himself in from the Football Ground end gives the County Ground a character of its own. Like a lot of cricketers, I clearly remember facing Ambrose for the first time. I was batting with Keith Greenfield and in my first taste of Ambrose I ended up facing all but three balls of an eight over spell. As someone once said, the best way to play fast bowling is from the other end!

In 1993, on our way to the Nat West final, Northants were cruising towards victory needing 92 in 20 overs with the advantage of seven wickets in hand. The match was held over until the following day when everyone bar the Sussex players and supporters presumed Northants would complete the formality of victory. Our bowlers performed heroics and Northants lost their remaining wickets for 52 runs.

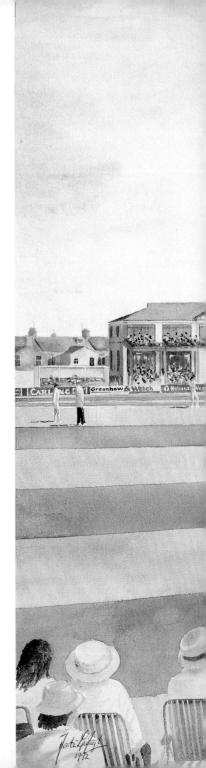

**County Ground Northampton**

*Watercolour*
*18 x 14*
*1992*
*Commissioned for Rob Bailey's Benefit*
*In private collection*

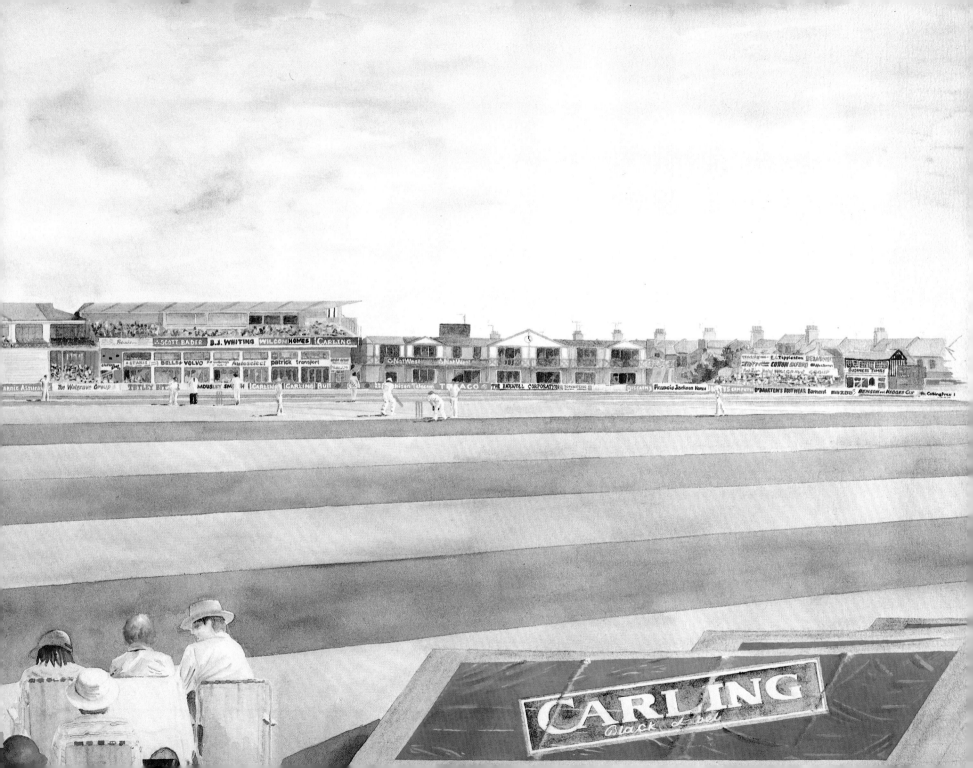

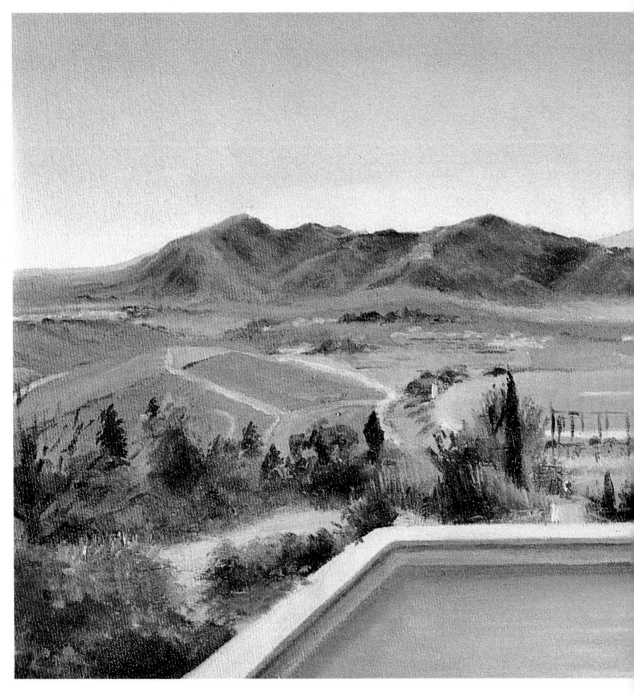

IN RECENT YEARS WE HAVE VISITED MALAGA and the Cartama Oval for pre-season training and preparation. It's an excellent way of preparing the squad for the season ahead, both physically and mentally, and gives us time to review the last season and plan for the next.

A group of Sussex players usually travel back to Malaga for an end of season break to

COSTA DEL SOL EDITION        13TH - 19TH OCTOBER 1994

## ent|Entertainment

### CRICKET NEWS - SUSSEX BEAT MALAGA

Sussex fielding a much stronger side than did the previous weekend against the Spanish National Team won by 18 runs in a close encounter at the Cartama Oval. The Sussex team included eight players who had first team experience this year.

Jamie Hall (62) and Martin Speight (43) put on 80 runs for the first wicket in even time before Speight was caught by Leith off the bowling of Douglas, wickets fell thereafter at regular intervals but a last wicket stand of 67 runs between David Smith and keeper Humphries helped the score along to 250 all out in the 39th over. Both Peter Langdale and Darren Shanley with 4 and 3 wickets respectively bowled well. In reply the MCA had a good start with Duncan Mackay and Alan Harris putting on 77 runs in their opening stand but in losing their next 7 wickets for only 50 runs their task became harder, a stand of 75 between Darren Shanly (63) and Roy Davis nearly pulled off an unexpected win for the home side.

**MATCH DETAILS**
Sussex C.C.C. XI - 250 all out
Jamie Hall 62 - Martin Speight 43
David Smith 29 not out
Peter Langdale 4 wickets 56 runs
Darren Shanley 3 wickets for 21 runs
Malaga C.A. - 232 all out
Darren Shanley 63 - Allan Harris 39 - Duncan Mackay 33
Peter Langdale 20 - Mike Biggs 17 - Roy Davis 16
Clarke, 4 wickets for 48 runs.
Gray 3 wickets for 40 runs.
Win for Sussex by 18 runs.

Next weekend, 21st, 22nd and 23rd October, sees two local sides, Costa del Sol Cricket Club, sponsored by Boddington ales and The Marbella Cricket Club, fly of to Mallorca for the Spanish Cup finals. Marbella Playa Menorca C.C. starting Friday afternoon the 21st October, in the one semi-final and in the other semi-final on Saturday, Costa del Sol C.C. play Barcelona C.C. The final and 3rd and 4th place play-off Matches will be played on Sunday, 23rd October.

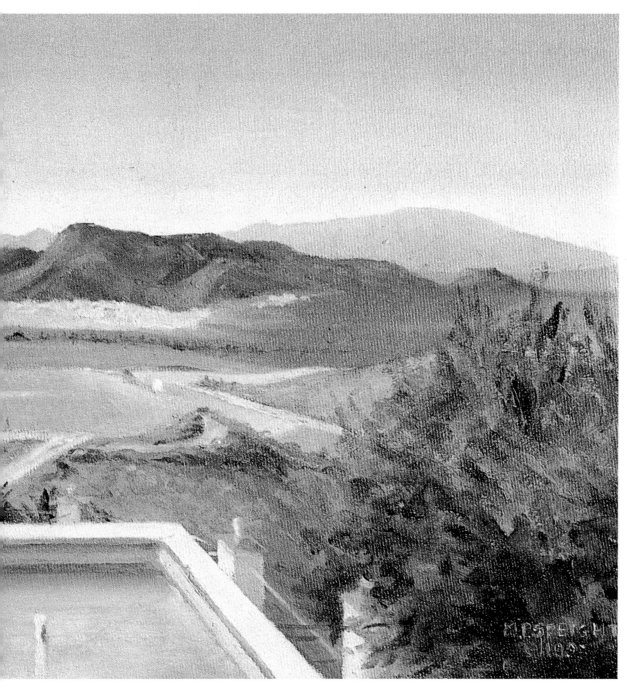

play local sides. Wherever ex-pats gather together a cricket team will be formed and it is nice to combine relaxation with some fun cricket at the end of a demanding domestic campaign.

Where else would I get an opportunity to paint a cricket oval with a swimming pool in the foreground.

**Cartama Oval**
Malaga

*Oil*
*20 x 10*
*1993*
*In private collection*
*in Malaga*

ALONG WITH THE SAFFRONS AT EASTBOURNE, Trent Bridge is a lucky ground for me and I always seem to score runs there. In 1992 I hit 166 against Notts which was doubly satisfying as they were championship leaders at the time. In contrast, I also remember facing the great Sir Richard Hadlee, and, like countless batsmen before me, remember being bowled by him. He was a superb bowler and if you are going to be bowled it may as well be by a master. I was the victim of a classic Hadlee dismissal; faster than earlier balls and nipping back to demolish my stumps before I knew what had happened. Alan Wells remarked to me at the time "that ball would have got out a lot better player than you Speighty."

Trent Bridge is a great cricket venue and in common with the other Test venues it generates an atmosphere of its own, even when there are only two men and a dog watching a county game. I watched Test cricket here as a boy and even now, as a player, I get a terrific thrill from actually playing at Trent Bridge.

**Trent Bridge**
Nottingham
*Watercolour*
*16 x 12*
*1994*
*In private collection*

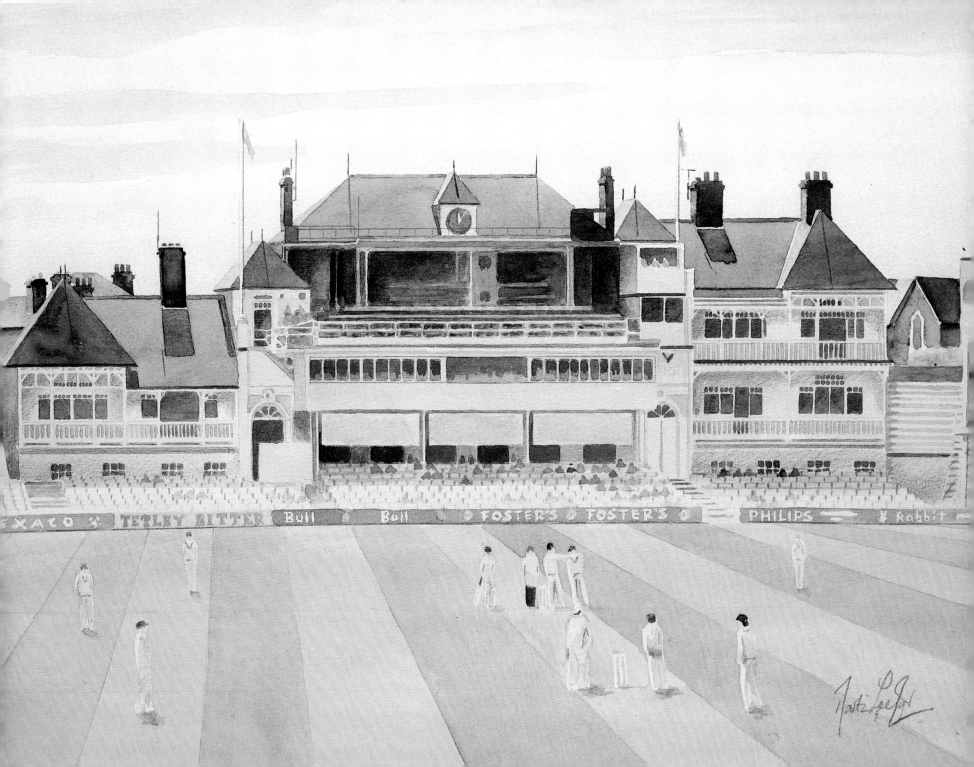

I PAINTED THE HAMPSHIRE HOME BASE FOR Bobby Parks' Benefit. It is a pleasant enough location, with a fairly handsome pavilion. I scored the second first-class fifty of my career here, making 58, and remember the game concerened largely because of the bowling rather than the batting. On a dry and dusty wicket Allan Green for Sussex and Chris Smith for Hampshire took a host of wickets, not bad for part-time bowlers.

## Speight's best

### by David Bennett

SUSSEX rookie Martin Speight hit a career-best 58 off Hampshire at Southampton today.

Sussex reached 154-5, a lead of 210, with the uncapped Speight the main contributor.

Occasional off spinner Chris Smith was Hampshire's most successful bowler with three wickets.

checked by an unbroken sixth wicket stand of 33 between Ian Gould and Colin Wells.

Overnight pair Speight and Paul Parker started the day watchfully against the medium-paced James and left arm spinner Rajesh Maru.

Speight pulled James for four in the third over for the first boundary of the day.

Parker helped himself to two boundaries and a single from Smith's first over but perished in the next over when he played a rash stroke against James and lost his off stump.

Parker had

● ALLAN GREEN

put on 41 for the second wicket and had taken Sussex's total to 60-2 when Allan Green, who took a career-best 6-82 yesterday, joined Speight.

Green had made five when he came down the wicket to Smith and edged the ball onto his stumps to leave Sussex on 81-2, at which stage they led by 137.

Speight reached only the second 50 of his career when he cover drove James for the seventh four of his innings. His half-century came off 78 balls.

When Maru came back for a second spell in place of James, Speight late-cut him to the boundary to pass his previous career-best of 50, made against Kent this season.

Speight had made 58 when, at 102, he hit a low return catch to Chris Smith.

Smith claimed

**County Ground Southampton**

*Watercolour*
*24 x 18*
*1990*
*Commissioned for*
*Bobby Parks' Benefit*
*In private collection*

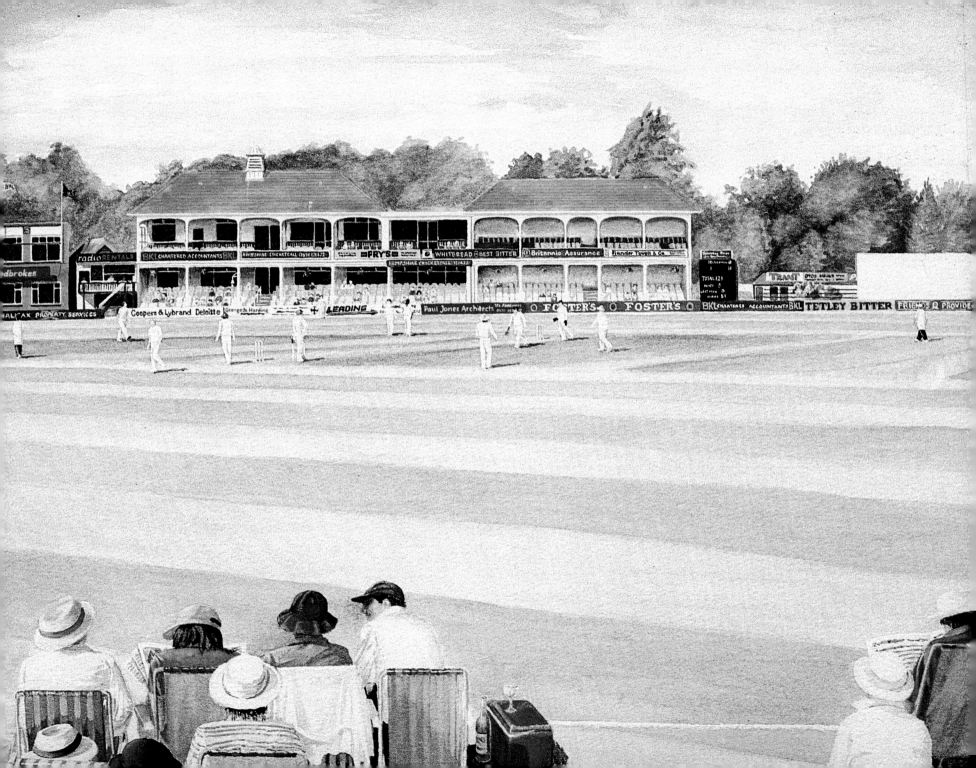

THE SCARBOROUGH CRICKET FESTIVAL IS known throughout the cricket world and started as far back as 1876. There can be few venues as attractive as this to stage a jamboree of cricket. Festival cricket is a very social occasion but it's competitive nonetheless.

I played there in 1993 and it rained for three days solid. At least this gave me ample time to sketch the ground and its surroundings. The pavilion is a marvellous subject to capture in a painting. It has everthing an artist could wish for in a cricket pavilion; colour from the red brick facade; a wrought iron balcony; a clock inset into the roof; the pleasing symmetry of the windows.

**Scarborough Festival**

*Watercolour*
*20 x 16*
*1994*
*In private collection*

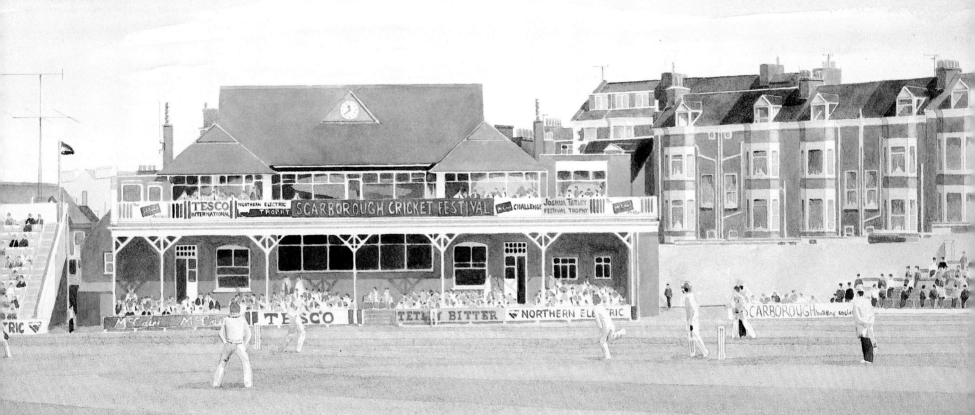

NEW ROAD IS A DELIGHT TO PAINT AND AN evocative place to play cricket. It is a ground steeped in cricket history, from Bradman's historic deeds to the contemporary feats of Botham and Hick.

All the world's superlatives have been used to describe New Road and everyone is

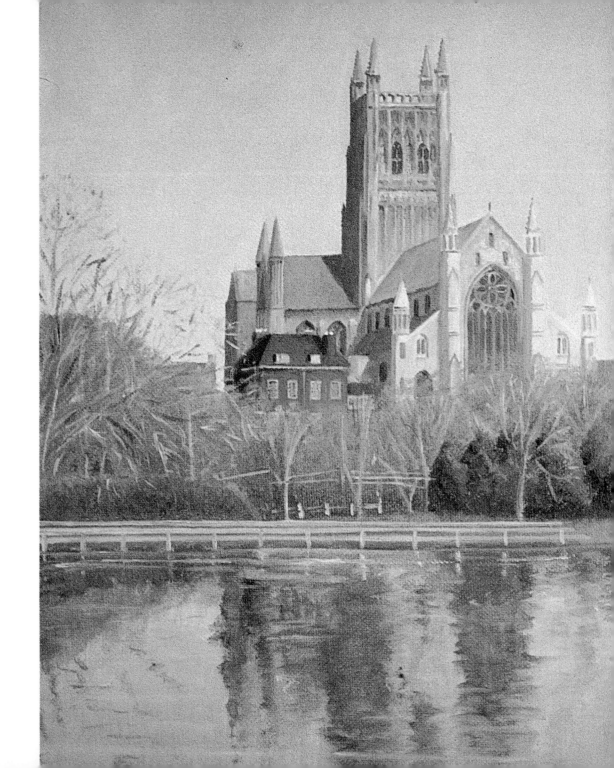

familiar with the classic view of Worcester Cathedral — as recognisable as the Lord's pavilion, but older and arguably more beautiful. It is equally well known that the River Severn frequently floods the ground during winter and it was this scene that I decided to paint.

**Worcester Under Water**

*Oil*
*16 x 12*
*1993*
*In private collection*

LORD'S IS QUITE SIMPLY LORD'S AND THERE CAN be little new to say about the home of cricket. To watch cricket at Lord's is a joy but to play there is magical. Even when the crowd is sparse, it feels as if the world of cricket is looking on.

The highlight of my career so far was to play in what was dubbed by the press as 'The Greatest One-Day Final Of All Time' – the 1993 Nat West final against Warwickshire. Walking out to bat, striding through the Long Room, I remember a Sussex member calling out to me "don't reverse sweep the first ball". I took his advice and settled for a regulation single to fine leg to get off the mark. My quick-fire 50 in 51 balls wasn't pre meditated by any means but the ball was moving about and I decided that attack was the best form of defence in the circumstances. The best advice I've ever been given is to play my own game and my batting partner on that day at Lord's, David Smith, repeated those very words when I came out to bat. The other comment I remember him making was while the ball was being retrieved from the pavilion during the last over of Tim Munton's spell. He strolled down the pitch and said "I don't suppose it's worth telling you that we've scored nine off this over already". The final ball of the over disappeared over mid-on as well! It was that sort of day. I still find it hard to believe that we scored 321 and lost the game, off the very last ball, in the gathering gloom. Contrary to what many people think, the fact that the game was so exciting and memorable is no consolation for losing.

I was looking for a new angle on Lord's and wanted to avoid yet another pretty picture of a full-house in the sunshine. So I decided to visit Lord's in the depths of winter when it was covered by a blanket of snow.

**Lord's Under Snow**

*Oil*
*14 x 10*
*1992*
*In private collection in Jersey*

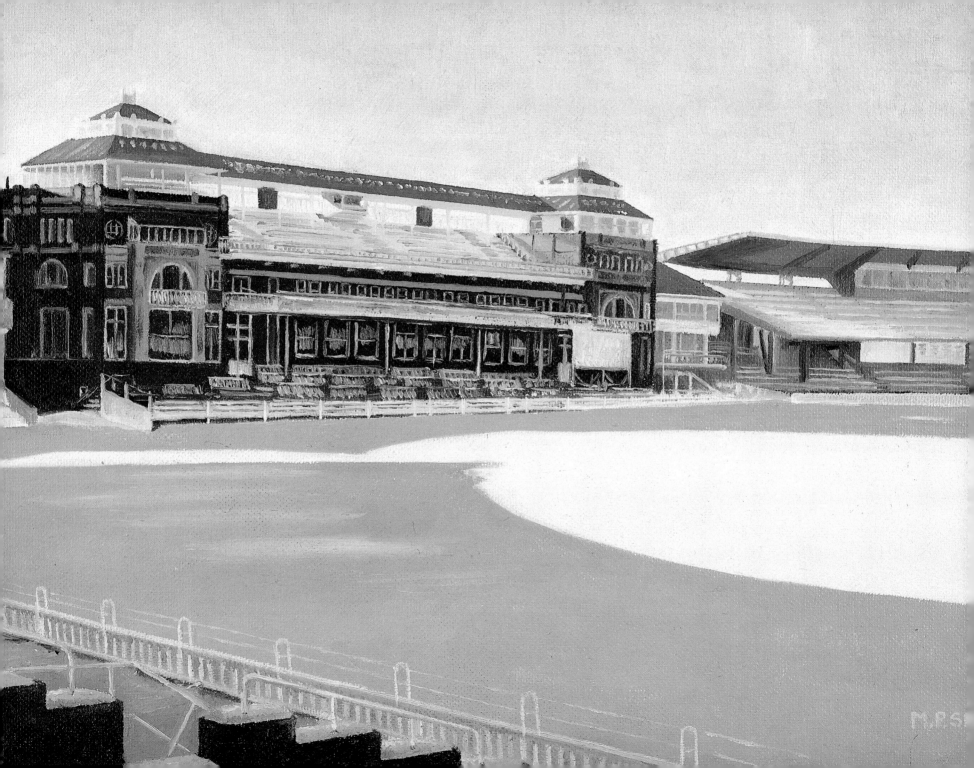

Many of the original paintings in this book have been especially commissioned . . .

● For cricket-lovers who want an original painting of a favourite scene.

● By businesses involved in the world of cricket.

● To commemorate a special event or anniversary.

To discuss a specific commission please contact Martin Speight personally at:

Sussex County Cricket Club
County Ground
Eaton Road
Hove
BN3 3AN